Teaching to
Transgress

Teaching to
Transgress

Education as the
Practice of Freedom

bell hooks

Routledge
Taylor & Francis Group
New York London

Published in 1994 by
Routledge
Taylor & Francis Group
711 Third Avenue
New York, NY 10017

Published in Great Britain by
Routledge
Taylor & Francis Group
2 Park Square
Milton Park, Abingdon
Oxon OX14 4RN

Routledge is an imprint of the Taylor & Francis Group, an informa business

Copyright © 1994 Gloria Watkins

Library of Congress Cataloging-in-Publication Data

hooks, bell.
 Teaching to transgress : education as the practice of freedom /
 bell hooks
 p. cm.
 Includes index
 ISBN 0-415-90807-8 — ISBN 0-415-90808-6 (pbk)
 1. Critical pedagogy. 2. Critical thinking—Study and teaching.
 3. Feminism and education. 4. Teaching. I. Title.
 LC196.H66 1994
 370.11′5—dc20 94-26248
 · CIP

to all my students,
especially to LaRon
who dances with angels
in gratitude for all the times we start over—begin again—
renew our joy in learning.

". . . to begin always anew, to make, to reconstruct, and to not
spoil, to refuse to bureaucratize the mind, to understand and
to live life as a process—live to become . . ."

—Paulo Freire

This page intentionally left blank

Contents

Introduction

Teaching to Transgress

In the weeks before the English Department at Oberlin College was about to decide whether or not I would be granted tenure, I was haunted by dreams of running away—of disappearing—yes, even of dying. These dreams were not a response to fear that I would not be granted tenure. They were a response to the reality that I *would* be granted tenure. I was afraid that I *would* be trapped in the academy forever.

Instead of feeling elated when I received tenure, I fell into a deep, life-threatening depression. Since everyone around me believed that I should be relieved, thrilled, proud, I felt "guilty" about my "real" feelings and could not share them with anyone. The lecture circuit took me to sunny California and the New Age world of my sister's house in Laguna Beach where I was able to chill out for a month. When I shared my feelings with my sister (she's a therapist), she reassured me that they were entirely appropriate because, she said, "You never wanted

to be a teacher. Since we were little, all you ever wanted to do was write." She was right. It was always assumed by everyone else that I would become a teacher. In the apartheid South, black girls from working-class backgrounds had three career choices. We could marry. We could work as maids. We could become school teachers. And since, according to the sexist thinking of the time, men did not really desire "smart" women, it was assumed that signs of intelligence sealed one's fate. From grade school on, I was destined to become a teacher.

But the dream of becoming a writer was always present within me. From childhood, I believed that I would teach *and* write. Writing would be the serious work, teaching would be the not-so-serious-I-need-to-make-a-living "job." Writing, I believed then, was all about private longing and personal glory, but teaching was about service, giving back to one's community. For black folks teaching—educating—was fundamentally political because it was rooted in antiracist struggle. Indeed, my all-black grade schools became the location where I experienced learning as revolution.

Almost all our teachers at Booker T. Washington were black women. They were committed to nurturing intellect so that we could become scholars, thinkers, and cultural workers—black folks who used our "minds." We learned early that our devotion to learning, to a life of the mind, was a counter-hegemonic act, a fundamental way to resist every strategy of white racist colonization. Though they did not define or articulate these practices in theoretical terms, my teachers were enacting a revolutionary pedagogy of resistance that was profoundly anticolonial. Within these segregated schools, black children who were deemed exceptional, gifted, were given special care. Teachers worked with and for us to ensure that we would fulfill our intellectual destiny and by so doing uplift the race. My teachers were on a mission.

To fulfill that mission, my teachers made sure they "knew" us. They knew our parents, our economic status, where we worshipped, what our homes were like, and how we were treated in the family. I went to school at a historical moment where I was being taught by the same teachers who had taught my mother, her sisters, and brothers. My effort and ability to learn was always contextualized within the framework of generational family experience. Certain behaviors, gestures, habits of being were traced back.

Attending school then was sheer joy. I loved being a student. I loved learning. School was the place of ecstasy—pleasure and danger. To be changed by ideas was pure pleasure. But to learn ideas that ran counter to values and beliefs learned at home was to place oneself at risk, to enter the danger zone. Home was the place where I was forced to conform to someone else's image of who and what I should be. School was the place where I could forget that self and, through ideas, reinvent myself.

School changed utterly with racial integration. Gone was the messianic zeal to transform our minds and beings that had characterized teachers and their pedagogical practices in our all-black schools. Knowledge was suddenly about information only. It had no relation to how one lived, behaved. It was no longer connected to antiracist struggle. Bussed to white schools, we soon learned that obedience, and not a zealous will to learn, was what was expected of us. Too much eagerness to learn could easily be seen as a threat to white authority.

When we entered racist, desegregated, white schools we left a world where teachers believed that to educate black children rightly would require a political commitment. Now, we were mainly taught by white teachers whose lessons reinforced racist stereotypes. For black children, education was no longer about the practice of freedom. Realizing this, I lost my love of school.

The classroom was no longer a place of pleasure or ecstasy. School was still a political place, since we were always having to counter white racist assumptions that we were genetically inferior, never as capable as white peers, even unable to learn. Yet, the politics were no longer counter-hegemonic. We were always and only responding and reacting to white folks.

That shift from beloved, all-black schools to white schools where black students were always seen as interlopers, as not really belonging, taught me the difference between education as the practice of freedom and education that merely strives to reinforce domination. The rare white teacher who dared to resist, who would not allow racist biases to determine how we were taught, sustained the belief that learning at its most powerful could indeed liberate. A few black teachers had joined us in the desegregation process. And, although it was more difficult, they continued to nurture black students even as their efforts were constrained by the suspicion they were favoring their own race.

Despite intensely negative experiences, I graduated from school still believing that education was enabling, that it enhanced our capacity to be free. When I began undergraduate work at Stanford University, I was enthralled with the process of becoming an insurgent black intellectual. It surprised and shocked me to sit in classes where professors were not excited about teaching, where they did not seem to have a clue that education was about the practice of freedom. During college, the primary lesson was reinforced: we were to learn obedience to authority.

In graduate school the classroom became a place I hated, yet a place where I struggled to claim and maintain the right to be an independent thinker. The university and the classroom began to feel more like a prison, a place of punishment and confinement rather than a place of promise and possibility. I

wrote my first book during those undergraduate years, even though it was not published until years later. I was writing; but more importantly I was preparing to become a teacher.

Accepting the teaching profession as my destiny, I was tormented by the classroom reality I had known both as an undergraduate and a graduate student. The vast majority of our professors lacked basic communication skills, they were not self-actualized, and they often used the classroom to enact rituals of control that were about domination and the unjust exercise of power. In these settings I learned a lot about the kind of teacher I did not want to become.

In graduate school I found that I was often bored in classes. The banking system of education (based on the assumption that memorizing information and regurgitating it represented gaining knowledge that could be deposited, stored and used at a later date) did not interest me. I wanted to become a critical thinker. Yet that longing was often seen as a threat to authority. Individual white male students who were seen as "exceptional," were often allowed to chart their intellectual journeys, but the rest of us (and particularly those from marginal groups) were always expected to conform. Nonconformity on our part was viewed with suspicion, as empty gestures of defiance aimed at masking inferiority or substandard work. In those days, those of us from marginal groups who were allowed to enter prestigious, predominantly white colleges were made to feel that we were there not to learn but to prove that we were the equal of whites. We were there to prove this by showing how well we could become clones of our peers. As we constantly confronted biases, an undercurrent of stress diminished our learning experience.

My reaction to this stress and to the ever-present boredom and apathy that pervaded my classes was to imagine ways that teaching and the learning experience could be different.

When I discovered the work of the Brazilian thinker Paulo
Freire, my first introduction to critical pedagogy, I found a
mentor and a guide, someone who understood that learning
could be liberatory. With his teachings and my growing under-
standing of the ways in which the education I had received in
all-black Southern schools had been empowering, I began to
develop a blueprint for my own pedagogical practice. Already
deeply engaged with feminist thinking, I had no difficulty
bringing that critique to Freire's work. Significantly, I felt that
this mentor and guide, whom I had never seen in the flesh,
would encourage and support my challenge to his ideas if he
was truly committed to education as the practice of freedom.
At the same time, I used his pedagogical paradigms to critique
the limitations of feminist classrooms.

During my undergraduate and graduate school years, only
white women professors were involved in developing Women's
Studies programs. And even though I taught my first class as a
graduate student on black women writers from a feminist per-
spective, it was in the context of a Black Studies program. At
that time, I found, white women professors were not eager to
nurture any interest in feminist thinking and scholarship on
the part of black female students if that interest included criti-
cal challenge. Yet their lack of interest did not discourage me
from involvement with feminist ideas or participation in the
feminist classroom. Those classrooms were the one space where
pedagogical practices were interrogated, where it was assumed
that the knowledge offered students would empower them to
be better scholars, to live more fully in the world beyond acad-
eme. The feminist classroom was the one space where students
could raise critical questions about pedagogical process. These
critiques were not always encouraged or well received, but they
were allowed. That small acceptance of critical interrogation
was a crucial challenge inviting us as students to think seriously
about pedagogy in relation to the practice of freedom.

When I entered my first undergraduate classroom to teach, I relied on the example of those inspired black women teachers in my grade school, on Freire's work, and on feminist thinking about radical pedagogy. I longed passionately to teach differently from the way I had been taught since high school. The first paradigm that shaped my pedagogy was the idea that the classroom should be an exciting place, never boring. And if boredom should prevail, then pedagogical strategies were needed that would intervene, alter, even disrupt the atmosphere. Neither Freire's work nor feminist pedagogy examined the notion of pleasure in the classroom. The idea that learning should be exciting, sometimes even "fun," was the subject of critical discussion by educators writing about pedagogical practices in grade schools, and sometimes even high schools. But there seemed to be no interest among either traditional or radical educators in discussing the role of excitement in higher education.

Excitement in higher education was viewed as potentially disruptive of the atmosphere of seriousness assumed to be essential to the learning process. To enter classroom settings in colleges and universities with the will to share the desire to encourage excitement, was to transgress. Not only did it require movement beyond accepted boundaries, but excitement could not be generated without a full recognition of the fact that there could never be an absolute set agenda governing teaching practices. Agendas had to be flexible, had to allow for spontaneous shifts in direction. Students had to be seen in their particularity as individuals (I drew on the strategies my grade-school teachers used to get to know us) and interacted with according to their needs (here Freire was useful). Critical reflection on my experience as a student in unexciting classrooms enabled me not only to imagine that the classroom could be exciting but that this excitement could co-exist with and even stimulate serious intellectual and/or academic engagement.

But excitement about ideas was not sufficient to create an exciting learning process. As a classroom community, our capacity to generate excitement is deeply affected by our interest in one another, in hearing one another's voices, in recognizing one another's presence. Since the vast majority of students learn through conservative, traditional educational practices and concern themselves only with the presence of the professor, any radical pedagogy must insist that everyone's presence is acknowledged. That insistence cannot be simply stated. It has to be demonstrated through pedagogical practices. To begin, the professor must genuinely *value* everyone's presence. There must be an ongoing recognition that everyone influences the classroom dynamic, that everyone contributes. These contributions are resources. Used constructively they enhance the capacity of any class to create an open learning community. Often before this process can begin there has to be some deconstruction of the traditional notion that only the professor is responsible for classroom dynamics. That responsibility is relative to status. Indeed, the professor will always be more responsible because the larger institutional structures will always ensure that accountability for what happens in the classroom rests with the teacher. It is rare that any professor, no matter how eloquent a lecturer, can generate through his or her actions enough excitement to create an exciting classroom. Excitement is generated through collective effort.

Seeing the classroom always as a communal place enhances the likelihood of collective effort in creating and sustaining a learning community. One semester, I had a very difficult class, one that completely failed on the communal level. Throughout the term, I thought that the major drawback inhibiting the development of a learning community was that the class was scheduled in the early morning, before nine. Almost always between a third and a half of the class was not fully awake. This, coupled with the tensions of "differences," was impossible to

overcome. Every now and then we had an exciting session, but mostly it was a dull class. I came to hate this class so much that I had a tremendous fear that I would not awaken to attend it; the night before (despite alarm clocks, wake-up calls, and the experiential knowledge that I had never forgotten to attend class) I still could not sleep. Rather than making me arrive sleepy, I tended to arrive wired, full of an energy few students mirrored.

Time was just one of the factors that prevented this class from becoming a learning community. For reasons I cannot explain it was also full of "resisting" students who did not want to learn new pedagogical processes, who did not want to be in a classroom that differed in any way from the norm. To these students, transgressing boundaries was frightening. And though they were not the majority, their spirit of rigid resistance seemed always to be more powerful than any will to intellectual openness and pleasure in learning. More than any other class I had taught, this one compelled me to abandon the sense that the professor could, by sheer strength of will and desire, make the classroom an exciting, learning community.

Before this class, I considered that *Teaching to Transgress: Education as the Practice of Freedom* would be a book of essays mostly directed to teachers. After the class ended, I began writing with the understanding that I was speaking to and with both students and professors. The scholarly field of writing on critical pedagogy and/or feminist pedagogy continues to be primarily a discourse engaged by white women and men. Freire, too, in conversation with me, as in much of his written work, has always acknowledged that he occupies the location of white maleness, particularly in this country. But the work of various thinkers on radical pedagogy (I use this term to include critical and/or feminist perspectives) has in recent years truly included a recognition of differences—those determined by class, race, sexual practice, nationality, and so on. Yet this movement forward does not seem to coincide with any significant

increase in black or other nonwhite voices joining discussions about radical pedagogical practices.

My pedagogical practices have emerged from the mutually illuminating interplay of anticolonial, critical, and feminist pedagogies. This complex and unique blending of multiple perspectives has been an engaging and powerful standpoint from which to work. Expanding beyond boundaries, it has made it possible for me to imagine and enact pedagogical practices that engage directly both the concern for interrogating biases in curricula that reinscribe systems of domination (such as racism and sexism) while simultaneously providing new ways to teach diverse groups of students.

In this book I want to share insights, strategies, and critical reflections on pedagogical practice. I intend these essays to be an intervention—countering the devaluation of teaching even as they address the urgent need for changes in teaching practices. They are meant to serve as constructive commentary. Hopeful and exuberant, they convey the pleasure and joy I experience teaching; these essays are celebratory! To emphasize that the pleasure of teaching is an act of resistance countering the overwhelming boredom, uninterest, and apathy that so often characterize the way professors and students feel about teaching and learning, about the classroom experience.

Each essay addresses common themes that surface again and again in discussions of pedagogy, offering ways to rethink teaching practices and constructive strategies to enhance learning. Written separately for a variety of contexts there is unavoidably some degree of overlap; ideas are repeated, key phrases used again and again. Even though I share strategies, these works do not offer blueprints for ways to make the classroom an exciting place for learning. To do so would undermine the insistence that engaged pedagogy recognize each classroom as different, that strategies must constantly be

changed, invented, reconceptualized to address each new teaching experience.

Teaching is a performative act. And it is that aspect of our work that offers the space for change, invention, spontaneous shifts, that can serve as a catalyst drawing out the unique elements in each classroom. To embrace the performative aspect of teaching we are compelled to engage "audiences," to consider issues of reciprocity. Teachers are not performers in the traditional sense of the word in that our work is not meant to be a spectacle. Yet it is meant to serve as a catalyst that calls everyone to become more and more engaged, to become active participants in learning.

Just as the way we perform changes, so should our sense of "voice." In our everyday lives we speak differently to diverse audiences. We communicate best by choosing that way of speaking that is informed by the particularity and uniqueness of whom we are speaking to and with. In keeping with this spirit, these essays do not all sound alike. They reflect my effort to use language in ways that speak to specific contexts, as well as my desire to communicate with a diverse audience. To teach in varied communities not only our paradigms must shift but also the way we think, write, speak. The engaged voice must never be fixed and absolute but always changing, always evolving in dialogue with a world beyond itself.

These essays reflect my experience of critical discussions with teachers, students, and individuals who have entered my classes to observe. Multilayered, then, these essays are meant to stand as testimony, bearing witness to education as the practice of freedom. Long before a public ever recognized me as a thinker or writer, I was recognized in the classroom by students —seen by them as a teacher who worked hard to create a dynamic learning experience for all of us. Nowadays, I am recognized more for insurgent intellectual practice. Indeed, the

academic public that I encounter at my lectures always shows surprise when I speak intimately and deeply about the classroom. That public seemed particularly surprised when I said that I was working on a collection of essays about teaching. This surprise is a sad reminder of the way teaching is seen as a duller, less valuable aspect of the academic profession. This perspective on teaching is a common one. Yet it must be challenged if we are to meet the needs of our students, if we are to restore to education and the classroom excitement about ideas and the will to learn.

There is a serious crisis in education. Students often do not want to learn and teachers do not want to teach. More than ever before in the recent history of this nation, educators are compelled to confront the biases that have shaped teaching practices in our society and to create new ways of knowing, different strategies for the sharing of knowledge. We cannot address this crisis if progressive critical thinkers and social critics act as though teaching is not a subject worthy of our regard.

The classroom remains the most radical space of possibility in the academy. For years it has been a place where education has been undermined by teachers and students alike who seek to use it as a platform for opportunistic concerns rather than as a place to learn. With these essays, I add my voice to the collective call for renewal and rejuvenation in our teaching practices. Urging all of us to open our minds and hearts so that we can know beyond the boundaries of what is acceptable, so that we can think and rethink, so that we can create new visions, I celebrate teaching that enables transgressions—a movement against and beyond boundaries. It is that movement which makes education the practice of freedom.

1

Engaged Pedagogy

To educate as the practice of freedom is a way of teaching that anyone can learn. That learning process comes easiest to those of us who teach who also believe that there is an aspect of our vocation that is sacred; who believe that our work is not merely to share information but to share in the intellectual and spiritual growth of our students. To teach in a manner that respects and cares for the souls of our students is essential if we are to provide the necessary conditions where learning can most deeply and intimately begin.

Throughout my years as student and professor, I have been most inspired by those teachers who have had the courage to transgress those boundaries that would confine each pupil to a rote, assembly-line approach to learning. Such teachers approach students with the will and desire to respond to our unique beings, even if the situation does not allow the full emergence of a relationship based on mutual recognition. Yet the possibility of such recognition is always present.

Paulo Freire and the Vietnamese Buddhist monk Thich Nhat Hanh are two of the "teachers" who have touched me deeply with their work. When I first began college, Freire's thought gave me the support I needed to challenge the "banking system" of education, that approach to learning that is rooted in the notion that all students need to do is consume information fed to them by a professor and be able to memorize and store it. Early on, it was Freire's insistence that education could be the practice of freedom that encouraged me to create strategies for what he called "conscientization" in the classroom. Translating that term to critical awareness and engagement, I entered the classrooms with the conviction that it was crucial for me and every other student to be an active participant, not a passive consumer. Education as the practice of freedom was continually undermined by professors who were actively hostile to the notion of student participation. Freire's work affirmed that education can only be liberatory when everyone claims knowledge as a field in which we all labor. That notion of mutual labor was affirmed by Thich Nhat Hanh's philosophy of engaged Buddhism, the focus on practice in conjunction with contemplation. His philosophy was similar to Freire's emphasis on "praxis"—action and reflection upon the world in order to change it.

In his work Thich Nhat Hanh always speaks of the teacher as a healer. Like Freire, his approach to knowledge called on students to be active participants, to link awareness with practice. Whereas Freire was primarily concerned with the mind, Thich Nhat Hanh offered a way of thinking about pedagogy which emphasized wholeness, a union of mind, body, and spirit. His focus on a holistic approach to learning and spiritual practice enabled me to overcome years of socialization that had taught me to believe a classroom was diminished if students and professors regarded one another as "whole" human

beings, striving not just for knowledge in books, but knowledge about how to live in the world.

During my twenty years of teaching, I have witnessed a grave sense of dis-ease among professors (irrespective of their politics) when students want us to see them as whole human beings with complex lives and experiences rather than simply as seekers after compartmentalized bits of knowledge. When I was an undergraduate, Women's Studies was just finding a place in the academy. Those classrooms were the one space where teachers were willing to acknowledge a connection between ideas learned in university settings and those learned in life practices. And, despite those times when students abused that freedom in the classroom by only wanting to dwell on personal experience, feminist classrooms were, on the whole, one location where I witnessed professors striving to create participatory spaces for the sharing of knowledge. Nowadays, most women's studies professors are not as committed to exploring new pedagogical strategies. Despite this shift, many students still seek to enter feminist classrooms because they continue to believe that there, more than in any other place in the academy, they will have an opportunity to experience education as the practice of freedom.

Progressive, holistic education, "engaged pedagogy" is more demanding than conventional critical or feminist pedagogy. For, unlike these two teaching practices, it emphasizes well-being. That means that teachers must be actively committed to a process of self-actualization that promotes their own well-being if they are to teach in a manner that empowers students. Thich Nhat Hanh emphasized that "the practice of a healer, therapist, teacher or any helping professional should be directed toward his or herself first, because if the helper is unhappy, he or she cannot help many people." In the United States it is rare that anyone talks about teachers in university settings as

healers. And it is even more rare to hear anyone suggest that teachers have any responsibility to be self-actualized individuals.

Learning about the work of intellectuals and academics primarily from nineteenth-century fiction and nonfiction during my pre-college years, I was certain that the task for those of us who chose this vocation was to be holistically questing for self-actualization. It was the actual experience of college that disrupted this image. It was there that I was made to feel as though I was terribly naive about "the profession." I learned that far from being self-actualized, the university was seen more as a haven for those who are smart in book knowledge but who might be otherwise unfit for social interaction. Luckily, during my undergraduate years I began to make a distinction between the practice of being an intellectual/teacher and one's role as a member of the academic profession.

It was difficult to maintain fidelity to the idea of the intellectual as someone who sought to be whole—well-grounded in a context where there was little emphasis on spiritual well-being, on care of the soul. Indeed, the objectification of the teacher within bourgeois educational structures seemed to denigrate notions of wholeness and uphold the idea of a mind/body split, one that promotes and supports compartmentalization.

This support reinforces the dualistic separation of public and private, encouraging teachers and students to see no connection between life practices, habits of being, and the roles of professors. The idea of the intellectual questing for a union of mind, body, and spirit had been replaced with notions that being smart meant that one was inherently emotionally unstable and that the best in oneself emerged in one's academic work. This meant that whether academics were drug addicts, alcoholics, batterers, or sexual abusers, the only important aspect of our identity was whether or not our minds functioned, whether we were able to do our jobs in the classroom. The self was presumably emptied out the moment the thresh-

old was crossed, leaving in place only an objective mind—free of experiences and biases. There was fear that the conditions of that self would interfere with the teaching process. Part of the luxury and privilege of the role of teacher/professor today is the absence of any requirement that we be self-actualized. Not surprisingly, professors who are not concerned with inner well-being are the most threatened by the demand on the part of students for liberatory education, for pedagogical processes that will aid them in their own struggle for self-actualization.

Certainly it was naive for me to imagine during high school that I would find spiritual and intellectual guidance in university settings from writers, thinkers, scholars. To have found this would have been to stumble across a rare treasure. I learned, along with other students, to consider myself fortunate if I found an interesting professor who talked in a compelling way. Most of my professors were not the slightest bit interested in enlightenment. More than anything they seemed enthralled by the exercise of power and authority within their mini-kingdom, the classroom.

This is not to say that there were not compelling, benevolent dictators, but it is true to my memory that it was rare—absolutely, astonishingly rare—to encounter professors who were deeply committed to progressive pedagogical practices. I was dismayed by this; most of my professors were not individuals whose teaching styles I wanted to emulate.

My commitment to learning kept me attending classes. Yet, even so, because I did not conform—would not be an unquestioning, passive student—some professors treated me with contempt. I was slowly becoming estranged from education. Finding Freire in the midst of that estrangement was crucial to my survival as a student. His work offered both a way for me to understand the limitations of the type of education I was receiving and to discover alternative strategies for learning and teaching. It was particularly disappointing to encounter white

male professors who claimed to follow Freire's model even as their pedagogical practices were mired in structures of domination, mirroring the styles of conservative professors even as they approached subjects from a more progressive standpoint.

When I first encountered Paulo Freire, I was eager to see if his style of teaching would embody the pedagogical practices he described so eloquently in his work. During the short time I studied with him, I was deeply moved by his presence, by the way in which his manner of teaching exemplified his pedagogical theory. (Not all students interested in Freire have had a similar experience.) My experience with him restored my faith in liberatory education. I had never wanted to surrender the conviction that one could teach without reinforcing existing systems of domination. I needed to know that professors did not have to be dictators in the classroom.

this is liberating for the teacher as well

While I wanted teaching to be my career, I believed that personal success was intimately linked with self-actualization. My passion for this quest led me to interrogate constantly the mind/body split that was so often taken to be a given. Most professors were often deeply antagonistic toward, even scornful of, any approach to learning emerging from a philosophical standpoint emphasizing the union of mind, body, and spirit, rather than the separation of these elements. Like many of the students I now teach, I was often told by powerful academics that I was misguided to seek such a perspective in the academy. Throughout my student years I felt deep inner anguish. Memory of that pain returns as I listen to students express the concern that they will not succeed in academic professions if they want to be well, if they eschew dysfunctional behavior or participation in coercive hierarchies. These students are often fearful, as I was, that there are no spaces in the academy where the will to be self-actualized can be affirmed.

This fear is present because many professors have intensely hostile responses to the vision of liberatory education that con-

nects the will to know with the will to become. Within professorial circles, individuals often complain bitterly that students want classes to be "encounter groups." While it is utterly unreasonable for students to expect classrooms to be therapy sessions, it is appropriate for them to hope that the knowledge received in these settings will enrich and enhance them.

Currently, the students I encounter seem far more uncertain about the project of self-actualization than my peers and I were twenty years ago. They feel that there are no clear ethical guidelines shaping actions. Yet, while they despair, they are also adamant that education should be liberatory. They want and demand more from professors than my generation did. There are times when I walk into classrooms overflowing with students who feel terribly wounded in their psyches (many of them see therapists), yet I do not think that they want therapy from me. They do want an education that is healing to the uninformed, unknowing spirit. They do want knowledge that is meaningful. They rightfully expect that my colleagues and I will not offer them information without addressing the connection between what they are learning and their overall life experiences.

This demand on the students' part does not mean that they will always accept our guidance. This is one of the joys of education as the practice of freedom, for it allows students to assume responsibility for their choices. Writing about our teacher/student relationship in a piece for the *Village Voice*, "How to Run the Yard: Off-Line and into the Margins at Yale," one of my students, Gary Dauphin, shares the joys of working with me as well as the tensions that surfaced between us as he began to devote his time to pledging a fraternity rather than cultivating his writing:

> People think academics like Gloria [my given name] are all about difference: but what I learned from her was mostly about sameness, about what I had in common as a black man to people of color; to women and gays and lesbians and the poor and anyone else who

> wanted in. I did some of this learning by reading but
> most of it came from hanging out on the fringes of her
> life. I lived like that for a while, shuttling between high
> points in my classes and low points outside. Gloria was a
> safe haven . . . Pledging a fraternity is about as far away
> as you can get from her classroom, from the yellow
> kitchen where she used to share her lunch with students
> in need of various forms of sustenance.

This is Gary writing about the joy. The tension arose as we discussed his reason for wanting to join a fraternity and my disdain for that decision. Gary comments, "They represented a vision of black manhood that she abhorred, one where violence and abuse were primary ciphers of bonding and identity." Describing his assertion of autonomy from my influence he writes, "But she must have also known the limits of even her influence on my life, the limits of books and teachers."

Ultimately, Gary felt that the decision he had made to join a fraternity was not constructive, that I "had taught him openness" where the fraternity had encouraged one-dimensional allegiance. Our interchange both during and after this experience was an example of engaged pedagogy.

Through critical thinking—a process he learned by reading theory and actively analyzing texts—Gary experienced education as the practice of freedom. His final comments about me: "Gloria had only mentioned the entire episode once after it was over, and this to tell me simply that there are many kinds of choices, many kinds of logic. I could make those events mean whatever I wanted as long as I was honest." I have quoted his writing at length because it is testimony affirming engaged pedagogy. It means that my voice is not the only account of what happens in the classroom.

Engaged pedagogy necessarily values student expression. In her essay, "Interrupting the Calls for Student Voice in Libera-

tory Education: A Feminist Poststructuralist Perspective," Mimi Orner employs a Foucauldian framework to suggest that

> Regulatory and punitive means and uses of the confession bring to mind curricular and pedagogical practices which call for students to publicly reveal, even confess, information about their lives and cultures in the presence of authority figures such as teachers.

When education is the practice of freedom, students are not the only ones who are asked to share, to confess. Engaged pedagogy does not seek simply to empower students. Any classroom that employs a holistic model of learning will also be a place where teachers grow, and are empowered by the process. That empowerment cannot happen if we refuse to be vulnerable while encouraging students to take risks. Professors who expect students to share confessional narratives but who are themselves unwilling to share are exercising power in a manner that could be coercive. In my classrooms, I do not expect students to take any risks that I would not take, to share in any way that I would not share. When professors bring narratives of their experiences into classroom discussions it eliminates the possibility that we can function as all-knowing, silent interrogators. It is often productive if professors take the first risk, linking confessional narratives to academic discussions so as to show how experience can illuminate and enhance our understanding of academic material. But most professors must practice being vulnerable in the classroom, being wholly present in mind, body, and spirit.

Progressive professors working to transform the curriculum so that it does not reflect biases or reinforce systems of domination are most often the individuals willing to take the risks that engaged pedagogy requires and to make their teaching practices a site of resistance. In her essay, "On Race and Voice:

Challenges for Liberation Education in the 1990s," Chandra Mohanty writes that

> resistance lies in self-conscious engagement with dominant, normative discourses and representations and in the active creation of oppositional analytic and cultural spaces. Resistance that is random and isolated is clearly not as effective as that which is mobilized through systemic politicized practices of teaching and learning. Uncovering and reclaiming subjugated knowledge is one way to lay claims to alternative histories. But these knowledges need to be understood and defined pedagogically, as questions of strategy and practice as well as of scholarship, in order to transform educational institutions radically.

Professors who embrace the challenge of self-actualization will be better able to create pedagogical practices that engage students, providing them with ways of knowing that enhance their capacity to live fully and deeply.

2

A Revolution of Values

The Promise of Multicultural Change

Two summers ago I attended my twentieth high school reunion. It was a last-minute decision. I had just finished a new book. Whenever I finish a work, I always feel lost, as though a steady anchor has been taken away and there is no sure ground under my feet. During the time between ending one project and beginning another, I always have a crisis of meaning. I begin to wonder what my life is all about and what I have been put on this earth to do. It is as though immersed in a project I lose all sense of myself and must then, when the work is done, rediscover who I am and where I am going. When I heard that the reunion was happening, it seemed just the experience to bring me back to myself, to help in the process of rediscovery. Never having attended any of the past reunions, I did not know what to expect. I did know that this one would be different. For the first time we were about to have a racially integrated reunion. In past years, reunions had always been segregated. White folks

had their reunion on their side of town and black folks had a separate reunion.

None of us was sure what an integrated reunion would be like. Those periods in our adolescent lives of racial desegregation had been full of hostility, rage, conflict, and loss. We black kids had been angry that we had to leave our beloved all-black high school, Crispus Attucks, and be bussed halfway cross town to integrate white schools. We had to make the journey and thus bear the responsibility of making desegregation a reality. We had to give up the familiar and enter a world that seemed cold and strange, not our world, not our school. We were certainly on the margin, no longer at the center, and it hurt. It was such an unhappy time. I still remember my rage that we had to awaken an hour early so that we could be bussed to school before the white students arrived. We were made to sit in the gymnasium and wait. It was believed that this practice would prevent outbreaks of conflict and hostility since it removed the possibility of social contact before classes began. Yet, once again, the burden of this transition was placed on us. The white school was desegregated, but in the classroom, in the cafeteria, and in most social spaces racial apartheid prevailed. Black and white students who considered ourselves progressive rebelled against the unspoken racial taboos meant to sustain white supremacy and racial apartheid even in the face of desegregation. The white folks never seemed to understand that our parents were no more eager for us to socialize with them than they were to socialize with us. Those of us who wanted to make racial equality a reality in every area of our life were threats to the social order. We were proud of ourselves, proud of our willingness to transgress the rules, proud to be courageous.

Part of a small integrated clique of smart kids who considered ourselves "artists," we believed we were destined to create outlaw culture where we would live as Bohemians forever free; we were certain of our radicalness. Days before the reunion, I

was overwhelmed by memories and shocked to discover that
our gestures of defiance had been nowhere near as daring as
they had seemed at the time. Mostly, they were acts of resis-
tance that did not truly challenge the status quo. One of my
best buddies during that time was white and male. He had an
old gray Volvo that I loved to ride in. Every now and then he
would give me a ride home from school if I missed the bus—an
action which angered and disturbed those who saw us. Friend-
ship across racial lines was bad enough, but across gender it was
unheard of and dangerous. (One day, we found out just how
dangerous when grown white men in a car tried to run us off
the road.) Ken's parents were religious. Their faith compelled
them to live out a belief in racial justice. They were among the
first white folks in our community to invite black folks to come
to their house, to eat at their table, to worship together with
them. As one of Ken's best buddies, I was welcome in their
house. After hours of discussion and debate about possible dan-
gers, my parents agreed that I could go there for a meal. It was
my first time eating together with white people. I was 16 years
old. I felt then as though we were making history, that we were
living the dream of democracy, creating a culture where equali-
ty, love, justice, and peace would shape America's destiny.

After graduation, I lost touch with Ken even though he
always had a warm place in my memory. I thought of him when
meeting and interacting with liberal white folks who believed
that having a black friend meant that they were not racist, who
sincerely believed that they were doing us a favor by extending
offers of friendly contact for which they felt they should be
rewarded. I thought of him during years of watching white folks
play at unlearning racism but walking away when they encoun-
tered obstacles, rejection, conflict, pain. Our high school
friendship had been forged not because we were black and
white but because we shared a similar take on reality. Racial dif-
ference meant that we had to struggle to claim the integrity of

that bonding. We had no illusions. We knew there would be obstacles, conflict, and pain. In white supremacist capitalist patriarchy—words we never used then—we knew we would have to pay a price for this friendship, that we would need to possess the courage to stand up for our belief in democracy, in racial justice, in the transformative power of love. We valued the bond between us enough to meet the challenge.

Days before the reunion, remembering the sweetness of that friendship, I felt humbled by the knowledge of what we give up when we are young, believing that we will find something just as good or better someday, only to discover that not to be so. I wondered just how it could be that Ken and I had ever lost contact with one another. Along the way I had not found white folks who understood the depth and complexity of racial injustice, and who were as willing to practice the art of living a nonracist life, as folks were then. In my adult life I have seen few white folks who are really willing to go the distance to create a world of racial equality—white folks willing to take risks, to be courageous, to live against the grain. I went to the reunion hoping that I would have a chance to see Ken face-to-face, to tell him how much I cherished all that we had shared, to tell him—in words which I never dared to say to any white person back then—simply that I loved him.

Remembering this past, I am most struck by our passionate commitment to a vision of social transformation rooted in the fundamental belief in a radically democratic idea of freedom and justice for all. Our notions of social change were not fancy. There was no elaborate postmodern political theory shaping our actions. We were simply trying to change the way we went about our everyday lives so that our values and habits of being would reflect our commitment to freedom. Our major concern then was ending racism. Today, as I witness the rise in white supremacy, the growing social and economic apartheid that separates white and black, the haves and the have-nots, men

and women, I have placed alongside the struggle to end racism a commitment to ending sexism and sexist oppression, to eradicating systems of class exploitation. Aware that we are living in a culture of domination, I ask myself now, as I did more than twenty years ago, what values and habits of being reflect my/ our commitment to freedom.

intersectionality

In retrospect, I see that in the last twenty years I have encountered many folks who say they are committed to freedom and justice for all even though the way they live, the values and habits of being they institutionalize daily, in public and private rituals, help maintain the culture of domination, help create an unfree world. In the book *Where Do We Go From Here? Chaos or Community*, Martin Luther King, Jr. told the citizens of this nation, with prophetic insight, that we would be unable to go forward if we did not experience a "true revolution of values." He assured us that

> the stability of the large world house which is ours will involve a revolution of values to accompany the scientific and freedom revolutions engulfing the earth. We must rapidly begin the shift from a "thing"-oriented society to a "person"-oriented society. When machines and computers, profit motives and property rights are considered more important than people, the giant triplets of racism, materialism and militarism are incapable of being conquered. A civilization can flounder as readily in the face of moral and spiritual bankruptcy as it can through financial bankruptcy.

Today, we live in the midst of that floundering. We live in chaos, uncertain about the possibility of building and sustaining community. The public figures who speak the most to us about a return to old-fashioned values embody the evils King describes. They are most committed to maintaining systems of

MAGA

domination—racism, sexism, class exploitation, and imperialism. They promote a perverse vision of freedom that makes it synonymous with materialism. They teach us to believe that domination is "natural," that it is right for the strong to rule over the weak, the powerful over the powerless. What amazes me is that so many people claim not to embrace these values and yet our collective rejection of them cannot be complete since they prevail in our daily lives.

These days, I am compelled to consider what forces keep us from moving forward, from having that revolution of values that would enable us to live differently. King taught us to understand that if "we are to have peace on earth" that "our loyalties must transcend our race, our tribe, our class, and our nation." Long before the word "multiculturalism" became fashionable, he encouraged us to "develop a world perspective." Yet, what we are witnessing today in our everyday life is not an eagerness on the part of neighbors and strangers to develop a world perspective but a return to narrow nationalism, isolationisms, and xenophobia. These shifts are usually explained in New Right and neoconservative terms as attempts to bring order to the chaos, to return to an (idealized) past. The notion of family evoked in these discussions is one in which sexist roles are upheld as stabilizing traditions. Nor surprisingly, this vision of family life is coupled with a notion of security that suggests we are always most safe with people of our same group, race, class, religion, and so on. No matter how many statistics on domestic violence, homicide, rape, and child abuse indicate that, in fact, the idealized patriarchal family is not a "safe" space, that those of us who experience any form of assault are more likely to be victimized by those who are like us rather than by some mysterious strange outsiders, these conservative myths persist. It is apparent that one of the primary reasons we have not experienced a revolution of values is that a culture of domination necessarily promotes addiction to lying and denial.

That lying takes the presumably innocent form of many
white people (and even some black folks) suggesting that
racism does not exist anymore, and that conditions of social
equality are solidly in place that would enable any black person
who works hard to achieve economic self-sufficiency. Forget
about the fact that capitalism requires the existence of a mass
underclass of surplus labor. Lying takes the form of mass media
creating the myth that feminist movement has completely
transformed society, so much so that the politics of patriarchal
power have been inverted and that men, particularly white
men, just like emasculated black men, have become the victims
of dominating women. So, it goes, all men (especially black
men) must pull together (as in the Clarence Thomas hearings)
to support and reaffirm patriarchal domination. Add to this
the widely held assumptions that blacks, other minorities, and
white women are taking jobs from white men, and that people
are poor and unemployed because they want to be, and it
becomes most evident that part of our contemporary crisis is
created by a lack of meaningful access to truth. That is to say,
individuals are not just presented untruths, but are told them
in a manner that enables most effective communication. When
this collective cultural consumption of and attachment to mis-
information is coupled with the layers of lying individuals do in
their personal lives, our capacity to face reality is severely
diminished as is our will to intervene and change unjust cir-
cumstances.

If we examine critically the traditional role of the university
in the pursuit of truth and the sharing of knowledge and infor-
mation, it is painfully clear that biases that uphold and main-
tain white supremacy, imperialism, sexism, and racism have
distorted education so that it is no longer about the practice of
freedom. The call for a recognition of cultural diversity, a
rethinking of ways of knowing, a deconstruction of old episte-
mologies, and the concomitant demand that there be a trans-

formation in our classrooms, in how we teach and what we teach, has been a necessary revolution—one that seeks to restore life to a corrupt and dying academy.

When everyone first began to speak about cultural diversity, it was exciting. For those of us on the margins (people of color, folks from working class backgrounds, gays, and lesbians, and so on) who had always felt ambivalent about our presence in institutions where knowledge was shared in ways that re-inscribed colonialism and domination, it was thrilling to think that the vision of justice and democracy that was at the very heart of civil rights movement would be realized in the acade-my. At last, there was the possibility of a learning community, a place where difference could be acknowledged, where we would finally all understand, accept, and affirm that our ways of knowing are forged in history and relations of power. Finally, we were all going to break through collective academic denial and acknowledge that the education most of us had received and were giving was not and is never politically neutral. Though it was evident that change would not be immediate, there was tremendous hope that this process we had set in motion would lead to a fulfillment of the dream of education as the practice of freedom.

Many of our colleagues were initially reluctant participants in this change. Many folks found that as they tried to respect "cultural diversity" they had to confront the limitations of their training and knowledge, as well as a possible loss of "authority." Indeed, exposing certain truths and biases in the classroom often created chaos and confusion. The idea that the class-room should always be a "safe," harmonious place was chal-lenged. It was hard for individuals to fully grasp the idea that recognition of difference might also require of us a willingness to see the classroom change, to allow for shifts in relations between students. A lot of people panicked. What they saw happening was not the comforting "melting pot" idea of cul-

tural diversity, the rainbow coalition where we would all be grouped together in our difference, but everyone wearing the same have-a-nice-day smile. This was the stuff of colonizing fantasy, a perversion of the progressive vision of cultural diversity. Critiquing this longing in a recent interview, "Critical Multiculturalism and Democratic Schooling" (in the *International Journal of Educational Reform*), Peter McLaren asserted:

> Diversity that somehow constitutes itself as a harmonious ensemble of benign cultural spheres is a conservative and liberal model of multiculturalism that, in my mind, deserves to be jettisoned because, when we try to make culture an undisturbed space of harmony and agreement where social relations exist within cultural forms of uninterrupted accords we subscribe to a form of social amnesia in which we forget that all knowledge is forged in histories that are played out in the field of social antagonisms.

the role of conflict in cultural formation

Many professors lacked strategies to deal with antagonisms in the classroom. When this fear joined with the refusal to change that characterized the stance of an old (predominantly white male) guard it created a space for disempowered collective backlash.

All of a sudden, professors who had taken issues of multiculturalism and cultural diversity seriously were backtracking, expressing doubts, casting votes in directions that would restore biased traditions or prohibit changes in faculty and curricula that were to bring diversity of representation and perspective. Joining forces with the old guard, previously open professors condoned tactics (ostracization, belittlement, and so on) used by senior colleagues to dissuade junior faculty members from making paradigm shifts that would lead to change. In one of my Toni Morrison seminars, as we went

around our circle voicing critical reflections on Morrison's language, a sort of classically white, blondish, J. Crew coed shared that one of her other English professors, an older white man (whose name none of us wanted her to mention), confided that he was so pleased to find a student still interested in reading literature—words—the language of texts and "not that race and gender stuff." Somewhat amused by the assumption he had made about her, she was disturbed by his conviction that conventional ways of critically approaching a novel could not coexist in classrooms that also offered new perspectives.

I then shared with the class my experience of being at a Halloween party. A new white male colleague, with whom I was chatting for the first time, went on a tirade at the mere mention of my Toni Morrison seminar, emphasizing that *Song of Solomon* was a weak rewrite of Hemingway's *For Whom the Bell Tolls*. Passionately full of disgust for Morrison he, being a Hemingway scholar, seemed to be sharing the often-heard concern that black women writers/thinkers are just poor imitations of "great" white men. Not wanting at that moment to launch into Unlearning Colonialism, Divesting of Racism and Sexism 101, I opted for the strategy taught to me by that in-denial-of-institutionalized-patriarchy, self-help book *Women Who Love Too Much*. I just said, "Oh!" Later, I assured him that I would read *For Whom the Bell Tolls* again to see if I would make the same connection. Both these seemingly trivial incidents reveal how deep-seated is the fear that any de-centering of Western civilizations, of the white male canon, is really an act of cultural genocide.

Some folks think that everyone who supports cultural diversity wants to replace one dictatorship of knowing with another, changing one set way of thinking for another. This is perhaps the gravest misperception of cultural diversity. Even though there are those overly zealous among us who hope to replace one set of absolutes with another, simply changing content,

this perspective does not accurately represent progressive visions of the way commitment to cultural diversity can constructively transform the academy. In all cultural revolutions there are periods of chaos and confusion, times when grave mistakes are made. If we fear mistakes, doing things wrongly, constantly evaluating ourselves, we will never make the academy a culturally diverse place where scholars and the curricula address every dimension of that difference.

As backlash swells, as budgets are cut, as jobs become even more scarce, many of the few progressive interventions that were made to change the academy, to create an open climate for cultural diversity are in danger of being undermined or eliminated. These threats should not be ignored. Nor should our collective commitment to cultural diversity change because we have not yet devised and implemented perfect strategies for them. To create a culturally diverse academy we must commit ourselves fully. Learning from other movements for social change, from civil rights and feminist liberation efforts, we must accept the protracted nature of our struggle and be willing to remain both patient and vigilant. To commit ourselves to the work of transforming the academy so that it will be a place where cultural diversity informs every aspect of our learning, we must embrace struggle and sacrifice. We cannot be easily discouraged. We cannot despair when there is conflict. Our solidarity must be affirmed by shared belief in a spirit of intellectual openness that celebrates diversity, welcomes dissent, and rejoices in collective dedication to truth.

Drawing strength from the life and work of Martin Luther King, Jr., I am often reminded of his profound inner struggle when he felt called by his religious beliefs to oppose the war in Vietnam. Fearful of alienating conservative bourgeois supporters, and of alienating the black church, King meditated on a passage from Romans, chapter 12, verse 2, which reminded him of the necessity of dissent, challenge and change: "Be not

conformed to this world but be ye transformed by the renewal
of your minds." All of us in the academy and in the culture as a
whole are called to renew our minds if we are to transform edu-
cational institutions—and society—so that the way we live,
teach, and work can reflect our joy in cultural diversity, our pas-
sion for justice, and our love of freedom.

3

Embracing Change

Teaching in a Multicultural World

Despite the contemporary focus on multiculturalism in our society, particularly in education, there is not nearly enough practical discussion of ways classroom settings can be transformed so that the learning experience is inclusive. If the effort to respect and honor the social reality and experiences of groups in this society who are nonwhite is to be reflected in a pedagogical process, then as teachers—on all levels, from elementary to university settings—we must acknowledge that our styles of teaching may need to change. Let's face it: most of us were taught in classrooms where styles of teachings reflected the notion of a single norm of thought and experience, which we were encouraged to believe was universal. This has been just as true for nonwhite teachers as for white teachers. Most of us learned to teach emulating this model. As a consequence, many teachers are disturbed by the political implications of a multicultural education because they fear losing control in a

classroom where there is no one way to approach a subject—
only multiple ways and multiple references.

Among educators there has to be an acknowledgment that
any effort to transform institutions so that they reflect a multi-
cultural standpoint must take into consideration the fears
teachers have when asked to shift their paradigms. There must
be training sites where teachers have the opportunity to express
those concerns while also learning to create ways to approach
the multicultural classroom and curriculum. When I first went
to Oberlin College, I was disturbed by what I felt was a lack of
understanding on the apart of many professors as to what the
multicultural classroom might be like. Chandra Mohanty, my
colleague in Women's Studies, shared these concerns. Though
we were both untenured, our strong belief that the Oberlin
campus was not fully facing the issue of changing curriculum
and teaching practices in ways that were progressive and pro-
moting of inclusion led us to consider how we might intervene
in this process. We proceeded from the standpoint that the vast
majority of Oberlin professors, who are overwhelmingly white,
were basically well-meaning, concerned about the quality of
education students receive on our campus, and therefore likely
to be supportive of any effort at education for critical con-
sciousness. Together, we decided to have a group of seminars
focusing on transformative pedagogy that would be open to all
professors. Initially, students were also welcome, but we found
that their presence inhibited honest discussion. On the first
night, for example, several white professors made comments
that could be viewed as horribly racist and the students left the
group to share what was said around the college. Since our
intent was to educate for critical consciousness, we did not want
the seminar setting to be a space where anyone would feel
attacked or their reputation as a teacher sullied. We did, howev-
er, want it to be a space for constructive confrontation and crit-

ical interrogation. To ensure that this could happen, we had to exclude students.

At the first meeting, Chandra (whose background is in education) and I talked about the factors that had influenced our pedagogical practices. I emphasized the impact of Freire's work on my thinking. Since my formative education took place in racially segregated schools, I spoke about the experience of learning when one's experience is recognized as central and significant and then how that changed with desegregation, when black children were forced to attend schools where we were regarded as objects and not subjects. Many of the professors present at the first meeting were disturbed by our overt discussion of political standpoints. Again and again, it was necessary to remind everyone that no education is politically neutral. Emphasizing that a white male professor in an English department who teaches only work by "great white men" is making a political decision, we had to work consistently against and through the overwhelming will on the part of folks to deny the politics of racism, sexism, heterosexism, and so forth that inform how and what we teach. We found again and again that almost everyone, especially the old guard, were more disturbed by the overt recognition of the role our political perspectives play in shaping pedagogy than by their passive acceptance of ways of teaching and learning that reflect biases, particularly a white supremacist standpoint.

To share in our efforts at intervention we invited professors from universities around the country to come and talk—both formally and informally—about the kind of work they were doing aimed at transforming teaching and learning so that a multicultural education would be possible. We invited then-Princeton professor of religion and philosophy Cornel West to give a talk on "decentering Western civilization." It was our hope that his very traditional training and his progressive prac-

tice as a scholar would give everyone a sense of optimism about
our ability to change. In the informal session, a few white male
professors were courageously outspoken in their efforts to say
that they could accept the need for change, but were uncertain
about the implications of the changes. This reminded us that it
is difficult for individuals to shift paradigms and that there must
be a setting for folks to voice fears, to talk about what they are
doing, how they are doing it, and why. One of our most useful
meetings was one in which we asked professors from different
disciplines (including math and science) to talk informally
about how their teaching had been changed by a desire to be
more inclusive. Hearing individuals describe concrete strate-
gies was an approach that helped dispel fears. It was crucial that
more traditional or conservative professors who had been will-
ing to make changes talk about motivations and strategies.

When the meetings concluded, Chandra and I initially felt a
tremendous sense of disappointment. We had not realized how
much faculty would need to unlearn racism to learn about col-
onization and decolonization and to fully appreciate the neces-
sity for creating a democratic liberal arts learning experience.

All too often we found a will to include those considered
"marginal" without a willingness to accord their work the same
respect and consideration given other work. In Women's Stud-
ies, for example, individuals will often focus on women of color
at the very end of the semester or lump everything about race
and difference together in one section. This kind of tokenism
is not multicultural transformation, but it is familiar to us as the
change individuals are most likely to make. Let me give anoth-
er example. What does it mean when a white female English
professor is eager to include a work by Toni Morrison on the
syllabus of her course but then teaches that work without ever
making reference to race or ethnicity? I have heard individual
white women "boast" about how they have shown students that
black writers are "as good" as the white male canon when they

do not call attention to race. Clearly, such pedagogy is not an interrogation of the biases conventional canons (if not all canons) establish, but yet another form of tokenism.

The unwillingness to approach teaching from a standpoint that includes awareness of race, sex, and class is often rooted in the fear that classrooms will be uncontrollable, that emotions and passions will not be contained. To some extent, we all know that whenever we address in the classroom subjects that students are passionate about there is always a possibility of confrontation, forceful expression of ideas, or even conflict. In much of my writing about pedagogy, particularly in classroom settings with great diversity, I have talked about the need to examine critically the way we as teachers conceptualize what the space for learning should be like. Many professors have conveyed to me their feeling that the classroom should be a "safe" place; that usually translates to mean that the professor lectures to a group of quiet students who respond only when they are called on. The experience of professors who educate for critical consciousness indicates that many students, especially students of color, may not feel at all "safe" in what appears to be a neutral setting. It is the absence of a feeling of safety that often promotes prolonged silence or lack of student engagement.

Making the classroom a democratic setting where everyone feels a responsibility to contribute is a central goal of transformative pedagogy. Throughout my teaching career, white professors have often voiced concern to me about nonwhite students who do not talk. As the classroom becomes more diverse, teachers are faced with the way the politics of domination are often reproduced in the educational setting. For example, white male students continue to be the most vocal in our classes. Students of color and some white women express fear that they will be judged as intellectually inadequate by these peers. I have taught brilliant students of color, many of them seniors, who have skillfully managed never to speak in class-

room settings. Some express the feeling that they are less likely to suffer any kind of assault if they simply do not assert their subjectivity. They have told me that many professors never showed any interest in hearing their voices. Accepting the decentering of the West globally, embracing multiculturalism, compels educators to focus attention on the issue of voice. Who speaks? Who listens? And why? Caring about whether all students fulfill their responsibility to contribute to learning in the classroom is not a common approach in what Freire has called the "banking system of education" where students are regarded merely as passive consumers. Since so many professors teach from that standpoint, it is difficult to create the kind of learning community that can fully embrace multiculturalism. Students are much more willing to surrender their dependency on the banking system of education than are their teachers. They are also much more willing to face the challenge of multiculturalism.

It has been as a teacher in the classroom setting that I have witnessed the power of a transformative pedagogy rooted in a respect for multiculturalism. Working with a critical pedagogy based on my understanding of Freire's teaching, I enter the classroom with the assumption that we must build "community" in order to create a climate of openness and intellectual rigor. Rather than focusing on issues of safety, I think that a feeling of community creates a sense that there is shared commitment and a common good that binds us. What we all ideally share is the desire to learn—to receive actively knowledge that enhances our intellectual development and our capacity to live more fully in the world. It has been my experience that one way to build community in the classroom is to recognize the value of each individual voice. In my classes, students keep journals and often write paragraphs during class which they read to one another. This happens at least once irrespective of class size. Most of the classes I teach are not small. They range anywhere

from thirty to sixty students, and at times I have taught more than one hundred. To hear each other (the sound of different voices), to listen to one another, is an exercise in recognition. It also ensures that no student remains invisible in the classroom. Some students resent having to make a verbal contribution, and so I have had to make it clear from the outset that this is a requirement in my classes. Even if there is a student present whose voice cannot be heard in spoken words, by "signing" (even if we cannot read the signs) they make their presence felt.

When I first entered the multicultural, multiethnic classroom setting I was unprepared. I did not know how to cope effectively with so much "difference." Despite progressive politics, and my deep engagement with the feminist movement, I had never before been compelled to work within a truly diverse setting and I lacked the necessary skills. This is the case with most educators. It is difficult for many educators in the United States to conceptualize how the classroom will look when they are confronted with the demographics which indicate that "whiteness" may cease to be the norm ethnicity in classroom settings on all levels. Hence, educators are poorly prepared when we actually confront diversity. This is why so many of us stubbornly cling to old patterns. As I worked to create teaching strategies that would make a space for multicultural learning, I found it necessary to recognize what I have called in other writing on pedagogy different "cultural codes." To teach effectively a diverse student body, I have to learn these codes. And so do students. This act alone transforms the classroom. The sharing of ideas and information does not always progress as quickly as it may in more homogeneous settings. Often, professors and students have to learn to accept different ways of knowing, new epistemologies, in the multicultural setting.

Just as it may be difficult for professors to shift their paradigms, it is equally difficult for students. I have always believed that students should enjoy learning. Yet I found that there was

"code switching"

much more tension in the diverse classroom setting where the philosophy of teaching is rooted in critical pedagogy and (in my case) in feminist critical pedagogy. The presence of tension—and at times even conflict—often meant that students did not enjoy my classes or love me, their professor, as I secretly wanted them to do. Teaching in a traditional discipline from the perspective of critical pedagogy means that I often encounter students who make complaints like, "I thought this was supposed to be an English class, why are we talking so much about feminism?" (Or, they might add, race or class.) In the transformed classroom there is often a much greater need to explain philosophy, strategy, intent than in the "norm" setting. I have found through the years that many of my students who bitch endlessly while they are taking my classes contact me at a later date to talk about how much that experience meant to them, how much they learned. In my professorial role I had to surrender my need for immediate affirmation of successful teaching (even though some reward is immediate) and accept that students may not appreciate the value of a certain standpoint or process straightaway. The exciting aspect of creating a classroom community where there is respect for individual voices is that there is infinitely more feedback because students do feel free to talk—and talk back. And, yes, often this feedback is critical. Moving away from the need for immediate affirmation was crucial to my growth as a teacher. I learned to respect that shifting paradigms or sharing knowledge in new ways challenges; it takes time for students to experience that challenge as positive.

Students taught me, too, that it is necessary to practice compassion in these new learning settings. I have not forgotten the day a student came to class and told me: "We take your class. We learn to look at the world from a critical standpoint, one that considers race, sex, and class. And we can't enjoy life anymore." Looking out over the class, across race, sexual preference, and

ethnicity, I saw students nodding their heads. And I saw for the first time that there can be, and usually is, some degree of pain involved in giving up old ways of thinking and knowing and learning new approaches. I respect that pain. And I include recognition of it now when I teach, that is to say, I teach about shifting paradigms and talk about the discomfort it can cause. White students learning to think more critically about questions of race and racism may go home for the holidays and suddenly see their parents in a different light. They may recognize nonprogressive thinking, racism, and so on, and it may hurt them that new ways of knowing may create estrangement where there was none. Often when students return from breaks I ask them to share with us how ideas that they have learned or worked on in the classroom impacted on their experience outside. This gives them both the opportunity to know that difficult experiences may be common and practice at integrating theory and practice: ways of knowing with habits of being. We practice interrogating habits of being as well as ideas. Through this process we build community.

Despite the focus on diversity, our desires for inclusion, many professors still teach in classrooms that are predominantly white. Often a spirit of tokenism prevails in those settings. This is why it is so crucial that "whiteness" be studied, understood, discussed—so that everyone learns that affirmation of multiculturalism, and an unbiased inclusive perspective, can and should be present whether or not people of color are present. Transforming these classrooms is as great a challenge as learning how to teach well in the setting of diversity. Often, if there is one lone person of color in the classroom she or he is objectified by others and forced to assume the role of "native informant." For example, a novel is read by a Korean American author. White students turn to the one student from a Korean background to explain what they do not understand. This places an unfair responsibility onto that student. Professors can

intervene in this process by making it clear from the outset that experience does not make one an expert, and perhaps even by explaining what it means to place someone in the role of "native informant." It must be stated that professors cannot intervene if they also see students as "native informants." Often, students have come to my office complaining about the lack of inclusion in another professor's class. For example, a course on social and political thought in the United States includes no work by women. When students complain to the teacher about this lack of inclusion, they are told to make suggestions of material that can be used. This often places an unfair burden on a student. It also makes it seem that it is only important to address a bias if there is someone complaining. Increasingly, students are making complaints because they want a democratic unbiased liberal arts education.

Multiculturalism compels educators to recognize the narrow boundaries that have shaped the way knowledge is shared in the classroom. It forces us all to recognize our complicity in accepting and perpetuating biases of any kind. Students are eager to break through barriers to knowing. They are willing to surrender to the wonder of re-learning and learning ways of knowing that go against the grain. When we, as educators, allow our pedagogy to be radically changed by our recognition of a multicultural world, we can give students the education they desire and deserve. We can teach in ways that transform consciousness, creating a climate of free expression that is the essence of a truly liberatory liberal arts education.

4

Paulo Freire

This is a playful dialogue with myself, Gloria Watkins, talking with bell hooks, my writing voice. I wanted to speak about Paulo and his work in this way for it afforded me an intimacy—a familiarity—I do not find it possible to achieve in the essay. And here I have found a way to share the sweetness, the solidarity I talk about.

Watkins:

Reading your books *Ain't I a Woman: Black Women and Feminism, Feminist Theory: From Margin to Center,* and *Talking Back,* it is clear that your development as a critical thinker has been greatly influenced by the work of Paulo Freire. Can you speak about why his work has touched your life so deeply?

hooks:

Years before I met Paulo Freire, I had learned so much from his work, learned new ways of thinking about social reality that were liberatory. Often when university stu-

45

dents and professors read Freire, they approach his work from a voyeuristic standpoint, where as they read they see two locations in the work, the subject position of Freire the educator (whom they are often more interested in than the ideas or subjects he speaks about) and the oppressed/marginalized groups he speaks about. In relation to these two subject positions, they position themselves as observers, as outsiders. When I came to Freire's work, just at that moment in my life when I was beginning to question deeply and profoundly the politics of domination, the impact of racism, sexism, class exploitation, and the kind of domestic colonization that takes place in the United States, I felt myself to be deeply identified with the marginalized peasants he speaks about, or with my black brothers and sisters, my comrades in Guinea-Bissau. You see, I was coming from a rural southern black experience, into the university, and I had lived through the struggle for racial desegregation and was in resistance without having a political language to articulate that process. Paulo was one of the thinkers whose work gave me a language. He made me think deeply about the construction of an identity in resistance. There was this one sentence of Freire's that became a revolutionary mantra for me: "We cannot enter the struggle as objects in order later to become subjects." Really, it is difficult to find words adequate to explain how this statement was like a locked door—and I struggled within myself to find the key—and that struggle engaged me in a process of critical thought that was transformative. This experience positioned Freire in my mind and heart as a challenging teacher whose work furthered my own struggle against the colonizing process—the colonizing mind-set.

GW: In your work, you indicate an ongoing concern with the process of decolonization, particularly as it affects

African Americans living within the white supremacist
culture of the United States. Do you see a link be-
tween the process of decolonization and Freire's focus
on "conscientization"?

bh: Oh, absolutely. Because the colonizing forces are so pow-
erful in this white supremacist capitalist patriarchy, it
seems that black people are always having to renew a com-
mitment to a decolonizing political process that should be
fundamental to our lives and is not. And so Freire's work,
in its global understanding of liberation struggles, always
emphasizes that this is the important initial stage of trans-
formation—that historical moment when one begins to
think critically about the self and identity in relation to
one's political circumstance. Again, this is one of the con-
cepts in Freire's work—and in my own work—that is fre-
quently misunderstood by readers in the United States.
Many times people will say to me that I seem to be sug-
gesting that it is enough for individuals to change how
they think. And you see, even their use of the *enough* tells
us something about the attitude they bring to this ques-
tion. It has a patronizing sound, one that does not convey
any heartfelt understanding of how a change in attitude
(though not a completion of any transformative process)
can be significant for colonized/oppressed people. Again
and again Freire has had to remind readers that he never
spoke of conscientization as an end itself, but always as it is
joined by meaningful praxis. In many different ways
Freire articulates this. I like when he talks about the neces-
sity of verifying in praxis what we know in consciousness:

> That means, and let us emphasize it, that human
> beings do not get beyond the concrete situation,
> the condition in which they find themselves,
> only by their consciousness or their intentions—
> however good those intentions may be. The pos-

sibilities that I had for transcending the narrow
limits of a five-by-two-foot cell in which I was
locked after the April 1964 coup d'etat were not
sufficient to change my condition as a prisoner. I
was always in the cell, deprived of freedom, even
if I could imagine the outside world. But on the
other hand, the praxis is not blind action,
deprived of intention or of finality. It is action
and reflection. Men and women are human
beings because they are historically constituted
as beings of praxis, and in the process they have
become capable of transforming the world—of
giving it meaning.

I think that so many progressive political movements fail
to have lasting impact in the United States precisely
because there is not enough understanding of "praxis."
This is what touches me about Antonio Faundez asserting
in *Learning to Question* that

> one of the things we learned in Chile in our
> early reflection on everyday life was that abstract
> political, religious or moral statements did not
> take concrete shape in acts by individuals. We
> were revolutionaries in the abstract, not in our
> daily lives. It seems to me essential that in our
> individual lives, we should day to day live out
> what we affirm.

It always astounds me when progressive people act as
though it is somehow a naive moral position to believe
that our lives must be a living example of our politics.

GW: There are many readers of Freire who feel that the sexist
language in his work, which went unchanged even after
the challenge of contemporary feminist movement and
feminist critique, is a negative example. When you first
read Freire what was your response to the sexism of his
language?

bh: There has never been a moment when reading Freire that I have not remained aware of not only the sexism of the language but the way he (like other progressive Third World political leaders, intellectuals, critical thinkers such as Fanon, Memmi, etc.) constructs a phallocentric paradigm of liberation—wherein freedom and the experience of patriarchal manhood are always linked as though they are one and the same. For me this is always a source of anguish for it represents a blind spot in the vision of men who have profound insight. And yet, I never wish to see a critique of this blind spot overshadow anyone's (and feminists' in particular) capacity to learn from the insights. This is why it is difficult for me to speak about sexism in Freire's work; it is difficult to find a language that offers a way to frame critique and yet maintain the recognition of all that is valued and respected in the work. It seems to me that the binary opposition that is so much embedded in Western thought and language makes it nearly impossible to project a complex response. Freire's sexism is indicated by the language in his early works, notwithstanding that there is so much that remains liberatory. There is no need to apologize for the sexism. Freire's own model of critical pedagogy invites a critical interrogation of this flaw in the work. But critical interrogation is not the same as dismissal.

GW: So you see no contradiction in your valuing of Freire's work and your commitment to feminist scholarship?

bh: It is feminist thinking that empowers me to engage in a constructive critique of Freire's work (which I needed so that as a young reader of his work I did not passively absorb the worldview presented) and yet there are many other standpoints from which I approach his work that enable me to experience its value, that make it possible for that work to touch me at the very core of my being. In

talking with academic feminists (usually white women) who feel they must either dismiss or devalue the work of Freire because of sexism, I see clearly how our different responses are shaped by the standpoint that we bring to the work. I came to Freire thirsty, dying of thirst (in that way that the colonized, marginalized subject who is still unsure of how to break the hold of the status quo, who longs for change, is needy, is thirsty), and I found in his work (and the work of Malcolm X, Fanon, etc.) a way to quench that thirst. To have work that promotes one's liberation is such a powerful gift that it does not matter so much if the gift is flawed. Think of the work as water that contains some dirt. Because you are thirsty you are not too proud to extract the dirt and be nourished by the water. For me this is an experience that corresponds very much to the way individuals of privilege respond to the use of water in the First World context. When you are privileged, living in one of the richest countries in the world, you can waste resources. And you can especially justify your disposal of something that you consider impure. Look at what most people do with water in this country. Many people purchase special water because they consider tap water unclean—and of course this purchasing is a luxury. Even our ability to see the water that come through the tap as unclean is itself informed by an imperialist consumer perspective. It is an expression of luxury and not just simply a response to the condition of water. If we approach the drinking of water that comes from the tap from a global perspective we would have to talk about it differently. We would have to consider what the vast majority of the people in the world who are thirsty must do to obtain water. Paulo's work has been living water for me.

GW: To what extent do you think your experience as an African American has made it possible for you to relate to Freire's work?.

bh: As I already suggested, growing up in a rural area in the
agrarian south, among black people who worked the
land, I felt intimately linked to the discussion of peasant
life in Freire's work and its relation to literacy. You know
there are no history books that really tell the story of how
difficult the politics of everyday life was for black people
in the racially segregated south when so many folks did
not read and were so often dependent on racist people to
explain, to read, to write. And I was among a generation
learning those skills, with an accessibility to education
that was still new. The emphasis on education as neces-
sary for liberation that black people made in slavery and
then on into reconstruction informed our lives. And so
Freire's emphasis on education as the practice of free-
dom made such immediate sense to me. Conscious of
the need for literacy from girlhood, I took with me to the
university memories of reading to folks, of writing for
folks. I took with me memories of black teachers in the
segregated school system who had been critical peda-
gogues providing us liberatory paradigms. It was this
early experience of a liberatory education in Booker T.
Washington and Crispus Attucks, the black schools of my
formative years, that made me forever dissatisfied with
the education I received in predominantly white settings.
And it was educators like Freire who affirmed that the
difficulties I had with the banking system of education,
with an education that in no way addressed my social real-
ity, were an important critique. Returning to the discus-
sion of feminism and sexism, I want to say that I felt
myself included in *Pedagogy of the Oppressed,* one of the
first Freire books I read, in a way that I never felt myself—
in my experience as a rural black person—included in
the first feminist books I read, works like *The Feminine
Mystique* and *Born Female.* In the United States we do not
talk enough about the way in which class shapes our

Women "entering the workforce"

perspective on reality. Since so many of the early feminist books really reflected a certain type of white bourgeois sensibility, this work did not touch many black women deeply; not because we did not recognize the common experiences women shared, but because those commonalities were mediated by profound differences in our realities created by the politics of race and class.

GW: Can you speak about the relationship between Freire's work and the development of your work as feminist theorist and social critic?

bh: Unlike feminist thinkers who make a clear separation between the work of feminist pedagogy and Freire's work and thought, for me these two experiences converge. Deeply committed to feminist pedagogy, I find that, much like weaving a tapestry, I have taken threads of Paulo's work and woven it into that version of feminist pedagogy I believe my work as writer and teacher embodies. Again, I want to assert that it was the intersection of Paulo's thought and the lived pedagogy of the many black teachers of my girlhood (most of them women) who saw themselves as having a liberatory mission to educate us in a manner that would prepare us to effectively resist racism and white supremacy, that has had a profound impact on my thinking about the art and practice of teaching. And though these black women did not openly advocate feminism (if they even knew the word) the very fact that they insisted on academic excellence and open critical thought for young black females was an antisexist practice.

GW: Be more specific about the work you have done that has been influenced by Freire.

bh: Let me say that I wrote *Ain't I a Woman: Black Women and Feminism* when I was an undergraduate (though it was not published until years later). This book was the concrete manifestation of my struggle with the question of moving

from object to subject—the very question Paulo had posed. And it is so easy, now that many, if not most, feminist scholars are willing to recognize the impact of race and class as factors that shape female identity, for everyone to forget that early on feminist movement was not a location that welcomed the radical struggle of black women to theorize our subjectivity. Freire's work (and that of many other teachers) affirmed my right as a subject in resistance to define my reality. His writing gave me a way to place the politics of racism in the United States in a global context wherein I could see my fate linked with that of colonized black people everywhere struggling to decolonize, to transform society. More than in the work of many white bourgeois feminist thinkers, there was always in Paulo's work recognition of the subject position of those most disenfranchised, those who suffer the gravest weight of oppressive forces (with the exception of his not acknowledging always the specific gendered realities of oppression and exploitation). This was a standpoint which affirmed my own desire to work from a lived understanding of the lives of poor black women. There has been only in recent years a body of scholarship in the United States that does not look at the lives of black people through a bourgeois lens, a fundamentally radical scholarship that suggests that indeed the experience of black people, black females, might tell us more about the experience of women in general than simply an analysis that looks first, foremost, and always at those women who reside in privileged locations. One of the reasons that Paulo's book, *Pedagogy in Process: The Letters to Guinea-Bissau*, has been important for my work is that it is a crucial example of how a privileged critical thinker approaches sharing knowledge and resources with those who are in need. Here is Paulo at one of those insightful moments. He writes:

Authentic help means that all who are involved
help each other mutually, growing together in
the common effort to understand the reality
which they seek to transform. Only through such
praxis—in which those who help and those who
are being helped help each other simultaneously
—can the act of helping become free from the
distortion in which the helper dominates the
helped.

the white savior

In American society where the intellectual—and specifi-
cally the black intellectual—has often assimilated and
betrayed revolutionary concerns in the interest of main-
taining class power, it is crucial and necessary for insur-
gent black intellectuals to have an ethics of struggle that
informs our relationship to those black people who have
not had access to ways of knowing shared in locations
of privilege.

GW: Comment, if you will, on Freire's willingness to be cri-
tiqued, especially by feminist thinkers.

bh: In so much of Paulo's work there is a generous spirit, a
quality of open-mindedness that I feel is often missing
from intellectual and academic arenas in U.S. society, and
feminist circles have not been an exception. Of course,
Paulo seems to grow more open as he ages. I, too, feel
myself more strongly committed to a practice of open-
mindedness, a willingness to engage critique as I age, and
I think the way we experience more profoundly the grow-
ing fascism in the world, even in so-called "liberal" circles,
reminds us that our lives, our work, must be an example.
In Freire's work in the last few years there are many
responses to the critiques made of his writing. And there
is that lovely critical exchange between him and Antonio
Faundez in *Learning to Question* on the question of lan-
guage, on Paulo's work in Guinea-Bissau. I learn from this

example, from seeing his willingness to struggle non-
defensively in print, naming shortcomings of insight,
changes in thought, new critical reflections.

GW: What was it like for you to interact personally with Paulo
Freire?

bh: For me our meeting was incredible; it made me a devoted
student and comrade of Paulo's for life. Let me tell you
this story. Some years ago now, Paulo was invited to the
University of Santa Cruz, where I was then a student and
teacher. He came to do workshops with Third World stu-
dents and faculty and to give a public lecture. I had not
heard even a whisper that he was coming, though many
folks knew how much his work meant to me. Then some-
how I found out that he was coming only to be told that
all the slots were filled for participants in the workshop. I
protested. And in the ensuing dialogue, I was told that I
had not been invited to the various meetings for fear that
I would disrupt the discussion of more important issues
by raising feminist critiques. Even though I was allowed to
participate when someone dropped out at the last min-
ute, my heart was heavy because already I felt that there
had been this sexist attempt to control my voice, to con-
trol the encounter. So, of course, this created a war with-
in myself because indeed I did want to interrogate Paulo
Freire personally about the sexism in his work. And so
with courtesy, I forged ahead at the meeting. Immedi-
ately individuals spoke against me raising these questions
and devalued their importance, Paulo intervened to say
that these questions were crucial and he addressed them.
Truthfully, I loved him at this moment for exemplifying
by his actions the principles of his work. So much would
have changed for me had he tried to silence or belittle a
feminist critique. And it was not enough for me that he
owned his "sexism," I want to know why he had not seen

that this aspect of earlier work be changed, be responded
to in writing by him. And he spoke then about making
more of a public effort to speak and write on these issues
—this has been evident in his later work.

GW: Were you more affected by his presence than his work?

bh: Another great teacher of mine (even though we have not
met) is the Vietnamese Buddhist monk Thich Nhat
Hanh. And he says in *The Raft Is Not the Shore* that "great
humans bring with them something like a hallowed
atmosphere, and when we seek them out, then we feel
peace, we feel love, we feel courage." His words appropri-
ately define what it was like for me to be in the presence
of Paulo. I spend hours alone with him, talking, listening
to music, eating ice cream at my favorite cafe. Seriously,
Thich Nhat Hanh teaches that a certain milieu is born at
the same time as a great teacher. And he says:

> When you [the teacher] come and stay one hour
> with us, you bring that milieu. . . . It is as though
> you bring a candle into the room. The candle is
> there; there is a kind of light-zone you bring in.
> When a sage is there and you sit near him, you
> feel light, you feel peace.

The lesson I learned from witnessing Paulo embody the
practice he describes in theory was profound. It entered
me in a way that writing can never touch one and it gave
me courage. It has not been easy for me to do the work I
do and reside in the academy (lately I think it has become
almost impossible) but one is inspired to persevere by the
witness of others. Freire's presence inspired me. And it
was not that I did not see sexist behavior on his part, only
that these contradictions are embraced as part of the
learning process, part of what one struggles to change—
and that struggle is often protracted.

GW: Have you anything more to say about Freire's response to feminist critique?

bh: I think it important and significant that despite feminist critiques of his work, which are often harsh, Paulo recognizes that he must play a role in feminist movements. This he declares in *Learning to Question:*

> If the women are critical, they have to accept our contribution as men, as well as the workers have to accept our contribution as intellectuals, because it is a duty and right that I have to participate in the transformation of society. Then, if the women must have the main responsibility in their struggle they have to know that their struggle also belongs to us, that is, to those men who don't accept the machista position in the world. The same is true of racism. As an apparent white man, because I always say that I am not quite sure of my whiteness, the question is to know if I am really against racism in a radical way. If I am, then I have a duty and a right to fight with black people against racism

antiracism

GW: Does Freire continue to influence your work? There is not the constant mention of him in your latest work as was the case with the first books.

bh: Though I may not quote Freire as much, he still teaches me. When I read *Learning to Question,* just at a time when I had begun to engage in critical reflections on black people and exile, there was so much there about the experience of exile that helped me. And I was thrilled with the book. It had a quality of that dialogue that is a true gesture of love that Paulo speaks about in other work. So it was from reading this book that I decided that it would be useful to do a dialogical work with the philosopher Cornel West. We have what Paulo calls "a talking book,"

Breaking Bread. Of course my great wish is to do such a book with Paulo. And then for some time I have been working on essays on death and dying, particularly African American ways of dying. Then just quite serendipitously I was searching for an epigraph for this work, and came across these lovely passages from Paulo that echo so intimately my own worldview that it was as though, to use an old southern phrase, "My tongue was in my friend's mouth." He writes:

> I like to live, to live my life intensely. I am the type of person who loves his life passionately. Of course, someday, I will die, but I have the impression that when I die, I will die intensely as well. I will die experimenting with myself intensely. For this reason I am going to die with an immense longing for life, since this is the way I have been living.

GW: Yes! I can hear you saying those very words. Any last comments?

bh: Only that words seem to be not good enough to evoke all that I have learned from Paulo. Our meeting had that quality of sweetness that lingers, that lasts for a lifetime; even if you never speak to the person again, see their face, you can always return in your heart to that moment when you were together to be renewed—that is a profound solidarity.

5

Theory as Liberatory Practice

I came to theory because I was hurting—the pain within me was so intense that I could not go on living. I came to theory desperate, wanting to comprehend—to grasp what was happening around and within me. Most importantly, I wanted to make the hurt go away. I saw in theory then a location for healing.

I came to theory young, when I was still a child. In *The Significance of Theory* Terry Eagleton says:

> Children make the best theorists, since they have not yet been educated into accepting our routine social practices as "natural," and so insist on posing to those practices the most embarrassingly general and fundamental questions, regarding them with a wondering estrangement which we adults have long forgotten. Since they do not yet grasp our social practices as inevitable, they do not see why we might not do things differently.

Whenever I tried in childhood to compel folks around me to do things differently, to look at the world differently, using

theory as intervention, as a way to challenge the status quo, I was punished. I remember trying to explain at a very young age to Mama why I thought it was highly inappropriate for Daddy, this man who hardly spoke to me, to have the right to discipline me, to punish me physically with whippings. Her response was to suggest I was losing my mind and in need of more frequent punishment.

Imagine if you will this young black couple struggling first and foremost to realize the patriarchal norm (that is of the woman staying home, taking care of the household and children while the man worked) even though such an arrangement meant that economically, they would always be living with less. Try to imagine what it must have been like for them, each of them working hard all day, struggling to maintain a family of seven children, then having to cope with one bright-eyed child relentlessly questioning, daring to challenge male authority, rebelling against the very patriarchal norm they were trying so hard to institutionalize.

It must have seemed to them that some monster had appeared in their midst in the shape and body of a child—a demonic little figure who threatened to subvert and undermine all that they were seeking to build. No wonder then that their response was to repress, contain, punish. No wonder that Mama would say to me, now and then, exasperated, frustrated, "I don't know where I got you from, but I sure wish I could give you back."

Imagine then if you will, my childhood pain. I did not feel truly connected to these strange people, to these familial folks who could not only fail to grasp my worldview but who just simply did not want to hear it. As a child, I didn't know where I had come from. And when I was not desperately seeking to belong to this family community that never seemed to accept or want me, I was desperately trying to discover the place of my belonging. I was desperately trying to find my way home.

How I envied Dorothy her journey in *The Wizard of Oz*, that she could travel to her worst fears and nightmares only to find at the end that "there is no place like home." Living in childhood without a sense of home, I found a place of sanctuary in "theorizing," in making sense out of what was happening. I found a place where I could imagine possible futures, a place where life could be lived differently. This "lived" experience of critical thinking, of reflection and analysis, because a place where I worked at explaining the hurt and making it go away. Fundamentally, I learned from this experience that theory could be a healing place.

Psychoanalyst Alice Miller lets you know in her introduction to the book *Prisoners of Childhood* that it was her own personal struggle to recover from the wounds of childhood that led her to rethink and theorize anew prevailing social and critical thought about the meaning of childhood pain, of child abuse. In her adult life, through her practice, she experienced theory as a healing place. Significantly, she had to imagine herself in the space of childhood, to look again from that perspective, to remember "crucial information, answers to questions which had gone unanswered throughout [her] study of philosophy and psychoanalysis." When our lived experience of theorizing is fundamentally linked to processes of self-recovery, of collective liberation, no gap exists between theory and practice. Indeed, what such experience makes more evident is the bond between the two—that ultimately reciprocal process wherein one enables the other.

Theory is not inherently healing, liberatory, or revolutionary. It fulfills this function only when we ask that it do so and direct our theorizing towards this end. When I was a child, I certainly did not describe the processes of thought and critique I engaged in as "theorizing." Yet, as I suggested in *Feminist Theory: From Margin to Center*, the possession of a term does not bring a process or practice into being; concurrently one may

practice theorizing without ever knowing/possessing the term, just as we can live and act in feminist resistance without ever using the word "feminism."

Often individuals who employ certain terms freely—terms like "theory" or "feminism"—are not necessarily practitioners whose habits of being and living most embody the action, the practice of theorizing or engaging in feminist struggle. Indeed, the privileged act of naming often affords those in power access to modes of communication and enables them to project an interpretation, a definition, a description of their work and actions, that may not be accurate, that may obscure what is really taking place. Katie King's essay "Producing Sex, Theory, and Culture: Gay/Straight Re-Mappings in Contemporary Feminism" (in *Conflicts in Feminism*) offers a very useful discussion of the way in which academic production of feminist theory formulated in hierarchical settings often enables women, particularly white women, with high status and visibility to draw upon the works of feminist scholars who may have less or no status, less or no visibility, without giving recognition to these sources. King discusses the way work is appropriated and the way readers will often attribute ideas to a well-known scholar/ feminist thinker, even if that individual has cited in her work that she is building on ideas gleaned from less well-known sources. Focusing particularly on the work of Chicana theorist Chela Sandoval, King states, "Sandoval has been published only sporadically and eccentrically, yet her circulating unpublished manuscripts are much more cited and often appropriated, even while the range of her influence is rarely understood." Though King risks positioning herself in a caretaker role as she rhetorically assumes the posture of feminist authority, determining the range and scope of Sandoval's influence, the critical point she works to emphasize is that the production of feminist theory is complex, that it is an individual practice less often than we think and usually emerges from engagement with collective sources. Echoing feminist theorists, especially

women of color who have worked consistently to resist the construction of restrictive critical boundaries within feminist thought, King encourages us to have an expansive perspective on the theorizing process.

Critical reflection on contemporary production of feminist theory makes it apparent that the shift from early conceptualizations of feminist theory (which insisted that it was most vital when it encouraged and enabled feminist practice) begins to occur or at least becomes most obvious with the segregation and institutionalization of the feminist theorizing process in the academy, with the privileging of written feminist thought/theory over oral narratives. Concurrently, the efforts of black women and women of color to challenge and deconstruct the category "woman"—the insistence on recognition that gender is not the sole factor determining constructions of femaleness—was a critical intervention, one which led to a profound revolution in feminist thought and truly interrogated and disrupted the hegemonic feminist theory produced primarily by academic women, most of whom were white.

In the wake of this disruption, the assault on white supremacy made manifest in alliances between white women academics and white male peers seems to have been formed and nurtured around common efforts to formulate and impose standards of critical evaluation that would be used to define what is theoretical and what is not. These standards often led to appropriation and/or devaluation of work that did not "fit," that was suddenly deemed not theoretical—or not theoretical enough. In some circles, there seems to be a direct connection between white feminist scholars turning towards critical work and theory by white men, and the turning away of white feminist scholars from fully respecting and valuing the critical insights and theoretical offerings of black women or women of color.

Work by women of color and marginalized groups or white women (for example, lesbians, sex radicals), especially if written in a manner that renders it accessible to a broad reading

public, is often de-legitimized in academic settings, even if that work enables and promotes feminist practice. Though such work is often appropriated by the very individuals setting restrictive critical standards, it is this work that they most often claim is not really theory. Clearly, one of the uses these individuals make of theory is instrumental. They use it to set up unnecessary and competing heirarchies of thought which reinscribe the politics of domination by designating work as either inferior, superior, or more or less worthy of attention. King emphasizes that "theory finds different uses in different locations." It is evident that one of the many uses of theory in academic locations is in the production of an intellectual class hierarchy where the only work deemed truly theoretical is work that is highly abstract, jargonistic, difficult to read, and containing obscure references. In Childers and hooks's "A Conversation about Race and Class" (also in *Conflicts in Feminism*) literary critic Mary Childers declares that it is highly ironic that "a certain kind of theoretical performance which only a small cadre of people can possibly understand" has come to be seen as representative of any production of critical thought that will be given recognition within many academic circles as "theory." It is especially ironic when this is the case with feminist theory. And, it is easy to imagine different locations, spaces outside academic exchange, where such theory would not only be seen as useless, but as politically nonprogressive, a kind of narcissistic, self-indulgent practice that most seeks to create a gap between theory and practice so as to perpetuate class elitism. There are so many settings in this country where the written word has only slight visual meaning, where individuals who cannot read or write can find no use for a published theory however lucid or opaque. Hence, any theory that cannot be shared in everyday conversation cannot be used to educate the public.

Imagine what a change has come about within feminist movements when students, most of whom are female, come to

Women's Studies classes and read what they are told is feminist theory only to feel that what they are reading has no meaning, cannot be understood, or when understood in no way connects to "lived" realities beyond the classroom. As feminist activists we might ask ourselves, of what use is feminist theory that assaults the fragile psyches of women struggling to throw off patriarchy's oppressive yoke? We might ask ourselves, of what use is feminist theory that literally beats them down, leaves them stumbling bleary-eyed from classroom settings feeling humiliated, feeling as though they could easily be standing in a living room or bedroom somewhere naked with someone who has seduced them or is going to, who also subjects them to a process of interaction that humiliates, that strips them of their sense of value? Clearly, a feminist theory that can do this may function to legitimize Women's Studies and feminist scholarship in the eyes of the ruling patriarchy, but it undermines and subverts feminist movements. Perhaps it is the existence of this most highly visible feminist theory that compels us to talk about the gap between theory and practice. For it is indeed the purpose of such theory to divide, separate, exclude, keep at a distance. And because this theory continues to be used to silence, censor, and devalue various feminist theoretical voices, we cannot simply ignore it. Yet, despite its uses as an instrument of domination, it may also contain important ideas, thoughts, visions, that could, if used differently, serve a healing, liberatory function. However, we cannot ignore the dangers it poses to feminist struggle which must be rooted in a theory that informs, shapes, and makes feminist practice possible.

Within feminist circles, many women have responded to hegemonic feminist theory that does not speak clearly to us by trashing theory, and, as a consequence, further promoting the false dichotomy between theory and practice. Hence, they collude with those whom they would oppose. By internalizing the false assumption that theory is not a social practice, they pro-

mote the formation within feminist circles of a potentially op-
pressive hierarchy where all concrete action is viewed as more
important than any theory written or spoken. Recently, I went
to a gathering of predominantly black women where we dis-
cussed whether or not black male leaders, such as Martin
Luther King and Malcolm X, should be subjected to feminist
critiques that pose hard questions about their stance on gender
issues. The entire discussion was less than two hours. As it drew
to a close, a black woman who had been particularly silent, said
that she was not interested in all this theory and rhetoric, all
this talk, that she was more interested in action, in doing some-
thing, that she was just "tired" of all the talk.

This woman's response disturbed me: it is a familiar reac-
tion. Perhaps in her daily life she inhabits a world different
from mine. In the world I live in daily, there are few occasions
when black women or women-of-color thinkers come together
to debate rigorously issues of race, gender, class, and sexuality.
Therefore, I did not know where she was coming from when
she suggested that the discussion we were having was common,
so common as to be something we could dispense with or do
without. I felt that we were engaged in a process of critical dia-
logue and theorizing that has long been taboo. Hence, from
my perspective we were charting new journeys, claiming for
ourselves as black women an intellectual terrain where we
could begin the collective construction of feminist theory.

In many black settings, I have witnessed the dismissal of
intellectuals, the putting down of theory, and remained silent.
I have come to see that silence is an act of complicity, one that
helps perpetuate the idea that we can engage in revolutionary
black liberation and feminist struggle without theory. Like
many insurgent black intellectuals, whose intellectual work and
teaching is often done in predominantly white settings, I am
often so pleased to be engaged with a collective group of black
folks that I do not want to make waves, or make myself an out-

sider by disagreeing with the group. In such settings, when the work of intellectuals is devalued, I have in the past rarely contested prevailing assumptions, or have spoken affirmatively or ecstatically about intellectual process. I was afraid that if I took a stance that insisted on the importance of intellectual work, particularly theorizing, or if I just simply stated that I thought it was important to ready widely, I would risk being seen as uppity, or as lording it over. I have often remained silent.

These risks to one's sense of self now seem trite when considered in relation to the crises we are facing as African Americans, to our desperate need to rekindle and sustain the flame of black liberation struggle. At the gathering I mentioned, I dared to speak, saying in response to the suggestion that we were just wasting our time talking, that I saw our words as an action, that our collective struggle to discuss issues of gender and blackness without censorship was subversive practice. Many of the issues that we continue to confront as black people —low self-esteem, intensified nihilism and despair, repressed rage and violence that destroys our physical and psychological well-being—cannot be addressed by survival strategies that have worked in the past. I insisted that we needed new theories rooted in an attempt to understand both the nature of our contemporary predicament and the means by which we might collectively engage in resistance that would transform our current reality. I was, however, not as rigorous and relentless as I would have been in a different setting in my efforts to emphasize the importance of intellectual work, the production of theory as a social practice that can be liberatory. Though not afraid to speak, I did not want to be seen as the one who "spoiled" the good time, the collective sense of sweet solidarity in blackness. This fear reminded me of what it was like more than ten years ago to be in feminist settings, posing questions about theory and practice, particularly about issues of race and racism that were seen as potentially disruptive of sisterhood and solidarity.

It seemed ironic that at a gathering called to honor Martin Luther King, Jr., who had often dared to speak and act in resistance to the status quo, black women were still negating our right to engage in oppositional political dialogue and debate, especially since this is not a common occurrence in black communities. Why did the black women there feel the need to police one another, to deny one another a space within blackness where we could talk theory without being self-conscious? Why, when we could celebrate together the power of a black male critical thinker who dared to stand apart, was there this eagerness to repress any viewpoint that would suggest we might collectively learn from the ideas and visions of insurgent black female intellectuals/theorists, who by the nature of the work they do are necessarily breaking with the stereotype that would have us believe the "real" black woman is always the one who speaks from the gut, who righteously praises the concrete over the abstract, the material over the theoretical?

Again and again, black women find our efforts to speak, to break silence and engage in radical progressive political debates, opposed. There is a link between the silencing we experience, the censoring, the anti-intellectualism in predominantly black settings that are supposedly supportive (like all-black woman space), and that silencing that takes place in institutions wherein black women and women of color are told that we cannot be fully heard or listened to because our work is not theoretical enough. In "Travelling Theory: Cultural Politics of Race and Representation," cultural critic Kobena Mercer reminds us that blackness is complex and multifaceted and that black people can be interpolated into reactionary and antidemocratic politics. Just as some elite academics who construct theories of "blackness" in ways that make it a critical terrain which only the chosen few can enter—using theoretical work on race to assert their authority over black experience, denying democratic access to the process of theory making—threaten collective black

liberation struggle, so do those among us who react to this by promoting anti-intellectualism by declaring all theory as worthless. By reinforcing the idea that there is a split between theory and practice or by creating such a split, both groups deny the power of liberatory education for critical consciousness, thereby perpetuating conditions that reinforce our collective exploitation and repression.

I was reminded recently of this dangerous anti-intellectualism when I agreed to appear on a radio show with a group of black women and men to discuss Shahrazad Ali's *The Blackman's Guide to Understanding the Blackwoman*. I listened to speaker after speaker express contempt for intellectual work, and speak against any call for the production of theory. One black woman was vehement in her insistence that "we don't need no theory." Ali's book, through written in plain language, in a style that makes use of engaging black vernacular, has a theoretical foundation. It is rooted in theories of patriarchy (for example, the sexist, essentialist belief that male domination of females is "natural"), that misogyny is the only possible response black men can have to any attempt by women to be fully self-actualized. Many black nationalists will eagerly embrace critical theory and thought as a necessary weapon in the struggle against white supremacy, but suddenly lose the insight that theory is important when it comes to questions of gender, of analyzing sexism and sexist oppression in the particular and specific ways it is manifest in black experience. The discussion of Ali's book is one of many possible examples illustrating the way contempt and disregard for theory undermines collective struggle to resist oppression and exploitation.

Within revolutionary feminist movements, within revolutionary black liberation struggles, we must continually claim theory as necessary practice within a holistic framework of liberatory activism. We must do more than call attention to ways theory is misused. We must do more than critique the conserva-

tive and at times reactionary uses some academic women make of feminist theory. We must actively work to call attention to the importance of creating a theory that can advance renewed feminist movements, particularly highlighting that theory which seeks to further feminist opposition to sexism, and sexist oppression. Doing this, we necessarily celebrate and value theory that can be and is shared in oral as well as written narrative.

Reflecting on my own work in feminist theory, I find writing —theoretical talk—to be most meaningful when it invites readers to engage in critical reflection and to engage in the practice of feminism. To me, this theory emerges from the concrete, from my efforts to make sense of everyday life experiences, from my efforts to intervene critically in my life and the lives of others. This to me is what makes feminist transformation possible. Personal testimony, personal experience, is such fertile ground for the production of liberatory feminist theory because it usually forms the base of our theory making. While we work to resolve those issues that are most pressing in daily life (our need for literacy, an end to violence against women and children, women's health and reproductive rights, and sexual freedom, to name a few), we engage in a critical process of theorizing that enables and empowers. I continue to be amazed that there is so much feminist writing produced and yet so little feminist theory that strives to speak to women, men and children about ways we might transform our lives via a conversion to feminist practice. Where can we find a body of feminist theory that is directed toward helping individuals integrate feminist thinking and practice into daily life? What feminist theory, for example, is directed toward assisting women who live in sexist households in their efforts to bring about feminist change?

We know that many individuals in the United States have used feminist thinking to educate themselves in ways that allow them to transform their lives. I am often critical of a life-style–based feminism, because I fear that any feminist transforma-

tional process that seeks to change society is easily co-opted if it is not rooted in a political commitment to mass-based feminist movement. Within white supremacist capitalist patriarchy, we have already witnessed the commodification of feminist thinking (just as we experience the commodification of blackness) in ways that make it seem as though one can partake of the "good" that these movements produce without any commitment to transformative politics and practice. In this capitalist culture, feminism and feminist theory are fast becoming a commodity that only the privileged can afford. This process of commodification is disrupted and subverted when as feminist activists we affirm our commitment to a politicized revolutionary feminist movement that has as its central agenda the transformation of society. From such a starting point, we automatically think of creating theory that speaks to the widest audience of people. I have written elsewhere, and shared in numerous public talks and conversations, that my decisions about writing style, about not using conventional academic formats, are political decisions motivated by the desire to be inclusive, to reach as many readers as possible in as many different locations. This decision has had consequences both positive and negative. Students at various academic institutions often complain that they cannot include my work on required reading lists for degree-oriented qualifying exams because their professors do not see it as scholarly enough. Any of us who create feminist theory and feminist writing in academic settings in which we are continually evaluated know that work deemed "not scholarly" or "not theoretical" can result in one not receiving deserved recognition and reward.

Now, in my life these negative responses seem insignificant when compared to the overwhelmingly positive responses to my work both in and outside the academy. Recently, I have received a spate of letters from incarcerated black men who read my work and wanted to share that they are working to

unlearn sexism. In one letter, the writer affectionately boasted that he has made my name a "household word around that prison." These men talk about solitary critical reflection, about using this feminist work to understand the implications of patriarchy as a force shaping their identities, their ideas of manhood. After receiving a powerful critical response by one of these black men to my book *Yearning: Race, Gender and Cultural Politics*, I closed my eyes and visualized that work being read, studied, talked about in prison settings. Since the location that has most spoken back to me critically about the study of my work is usually an academic one, I share this with you not to brag or be immodest, but to testify, to let you know from first-hand experience that all our feminist theory directed at transforming consciousness, that truly wants to speak with diverse audiences, does work: this is not a naive fantasy.

In more recent talks, I have spoken about how "blessed" I feel to have my work affirmed in this way, to be among those feminist theorists creating work that acts as a catalyst for social change across false boundaries. There were many times early on when my work was subjected to forms of dismissal and devaluation that created within me a profound despair. I think such despair has been felt by every black woman or woman-of-color thinker/theorist whose work is oppositional and moves against the grain. Certainly Michele Wallace has written poignantly in her introduction to the re-issue of *Black Macho and the Myth of the Superwoman* that she was devastated and for a time silenced by the negative critical responses to her early work.

I am grateful that I can stand here and testify that if we hold fast to our beliefs that feminist thinking must be shared with everyone, whether through talking or writing, and create theory with this agenda in mind we can advance feminist movement that folks will long—yes, yearn—to be a part of. I share feminist thinking and practice wherever I am. When asked to talk in

university settings, I search out other settings or respond to
those who search me out so that I can give the riches of femi-
nist thinking to anyone. Sometimes settings emerge sponta-
neously. At a black-owned restaurant in the South, for instance,
I sat for hours with a diverse group of black women and men
from various class backgrounds discussing issues of race, gen-
der and class. Some of us were college-educated, others were
not. We had a heated discussion of abortion, discussing
whether black women should have the right to choose. Several
of the Afrocentric black men present were arguing that the
male should have as much choice as the female. One of the
feminist black women present, a director of a health clinic for
women, spoke eloquently and convincingly about a woman's
right to choose.

During this heated discussion one of the black women pre-
sent who had been silent for a long time, who hesitated before
she entered the conversation because she was unsure about
whether or not she could convey the complexity of her thought
in black vernacular speech (in such a way that we, the listeners,
would hear and understand and not make fun of her words),
came to voice. As I was leaving, this sister came up to me and
grasped both my hands tightly, firmly, and thanked me for the
discussion. She prefaced her words of gratitude by sharing that
the conversation had not only enabled her to give voice to feel-
ings and ideas she had always "kept" to herself, but that by say-
ing it she had created a space for her and her partner to
change thought and action. She stated this to me directly, in-
tently, as we stood facing one another, holding my hands and
saying again and again, "there's been so much hurt in me." She
gave thanks that our meeting, our theorizing of race, gender,
and sexuality that afternoon had eased her pain, testifying that
she could feel the hurt going away, that she could feel a healing
taking place within. Holding my hands, standing body to body,

eye to eye, she allowed me to share empathically the warmth of that healing. She wanted me to bear witness, to hear again both the naming of her pain and the power that emerged when she felt the hurt go away.

It is not easy to name our pain, to make it a location for theorizing. Patricia Williams, in her essay "On Being the Object of Property" (in *The Alchemy of Race and Rights*), writes that even those of us who are "aware" are made to feel the pain that all forms of domination (homophobia, class exploitation, racism, sexism, imperialism) engender.

> There are moments in my life when I feel as though a part of me is missing. There are days when I feel so invisible that I can't remember what day of the week it is, when I feel so manipulated that I can't remember my own name, when I feel so lost and angry that I can't speak a civil word to the people who love me best. These are the times when I catch sight of my reflection in store windows and am surprised to see a whole person looking back . . . I have to close my eyes at such times and remember myself, draw an internal pattern that is smooth and whole.

It is not easy to name our pain, to theorize from that location.

I am grateful to the many women and men who dare to create theory from the location of pain and struggle, who courageously expose wounds to give us their experience to teach and guide, as a means to chart new theoretical journeys. Their work is liberatory. It not only enables us to remember and recover ourselves, it charges and challenges us to renew our commitment to an active, inclusive feminist struggle. We have still to collectively make feminist revolution. I am grateful that we are collectively searching as feminist thinkers/theorists for ways to make this movement happen. Our search leads us back to where it all began, to that moment when an individual woman

or child, who may have thought she was all alone, began a feminist uprising, began to name her practice, indeed began to formulate theory from lived experience. Let us imagine that this woman or child was suffering the pain of sexism and sexist oppression, that she wanted to make the hurt go away. I am grateful that I can be a witness, testifying that we can create a feminist theory, a feminist practice, a revolutionary feminist movement that can speak directly to the pain that is within folks, and offer them healing words, healing strategies, healing theory. There is no one among us who has not felt the pain of sexism and sexist oppression, the anguish that male domination can create in daily life, the profound and unrelenting misery and sorrow.

Mari Matsuda has told us that "we are fed a lie that there is no pain in war," and that patriarchy makes this pain possible. Catharine MacKinnon reminds us that "we know things with our lives and we live that knowledge, beyond what any theory has yet theorized." Making this theory is the challenge before us. For in its production lies the hope of our liberation, in its production lies the possibility of naming all our pain—of making all our hurt go away. If we create feminist theory, feminist movements that address this pain, we will have no difficulty building a mass based feminist resistance struggle. There will be no gap between feminist theory and feminist practice.

6

Essentialism and Experience

Individual black women engaged in feminist movement, writing feminist theory, have persisted in our efforts to deconstruct the category "woman" and argued that gender is not the sole determinant of woman's identity. That this effort has succeeded can be measured not only by the extent to which feminist scholars have confronted questions of race and racism but by the emerging scholarship that looks at the intertwining of race and gender. Often it is forgotten that the hope was not simply that feminist scholars and activists would focus on race and gender but that they would do so in a manner that would not reinscribe conventional oppressive hierarchies. Particularly, it was seen as crucial to building mass-based feminist movement that theory would not be written in a manner that would further erase and exclude black women and women of color, or, worse yet, include us in subordinate positions. Unfortunately, much feminist scholarship dashes these hopes, largely because critics fail to interrogate the location from which they speak, often assuming, as it is now fashionable to do, that there is no

need to question whether the perspective from which they write is informed by racist and sexist thinking, specifically as feminists perceive black women and women of color.

I was particularly reminded of this problem within feminist scholarship focusing on race and gender while reading Diana Fuss's *Essentially Speaking: Feminism, Nature and Difference.* Intrigued by Fuss's discussion of current debates about essentialism and her problematizing of the issue, I was intellectually excited. Throughout much of the book she offers a brilliant analysis that allows critics to consider the positive possibilities of essentialism, even as she raises relevant critiques of its limitations. In my writing on the subject ("The Politics of Radical Black Subjectivity," "Post-Modern Blackness" in *Yearning*), though not as specifically focused on essentialism as the Fuss discussion, I concentrate on the ways critiques of essentialism have usefully deconstructed the idea of a monolithic homogenous black identity and experience. I also discuss the way a totalizing critique of "subjectivity, essence, identity" can seem very threatening to marginalized groups, for whom it has been an active gesture of political resistance to name one's identity as part of a struggle to challenge domination. *Essentially Speaking* provided me with a critical framework that added to my understanding of essentialism, yet halfway through the Fuss book I began to feel dismayed.

That dismay began with my reading of "'Race' under Erasure? Poststructuralist Afro-American Literary Theory." Here, Fuss makes sweeping statements about African American literary criticism without offering any sense of the body of work she draws on to make her conclusions. Her pronouncements about the work of black feminist critics are particularly disturbing. Fuss asserts, "With the exception of the recent work of Hazel Carby and Hortense Spillers, black feminist critics have been reluctant to renounce essentialist critical positions and humanist literary practices." Curious to know what works would lend

themselves to this assessment, I was stunned to see Fuss cite only essays by Barbara Christian, Joyce Joyce, and Barbara Smith. While these individuals all do valuable literary criticism, they certainly do not represent all black feminist critics, particularly literary critics. Summing up her perspectives on black feminist writing in a few paragraphs, Fuss concentrates on black male literary critics Houston Baker and Henry Louis Gates, citing a significant body of their writings. It seems as though a racialized gender hierarchy is established in this chapter wherein the writing on "race" by black men is deemed worthier of in-depth study than the work of black women critics.

Her one-sentence dismissal and devaluation of work by most black feminist critics raises problematic questions. Since Fuss does not wish to examine work by black feminist critics comprehensively, it is difficult to grasp the intellectual groundwork forming the basis of her critique. Her comments on black feminist critics seem like additions to a critique that did not really start off including this work in its analysis. And as her reasons are not made explicit, I wonder why she needed to invoke the work of black feminist critics, and why she used it to place the work of Spillers and Carby in opposition to the writing of other black feminist critics. Writing from her perspective as a British black person from a West Indian background, Carby is by no means the first or only black woman critic, as Fuss suggests, to compel "us to interrogate the essentialism of traditional feminist historiography which posits a universalizing and hegemonizing notion of global sisterhood." If Carby's work is more convincing to Fuss than other writing by black feminists she has read (if indeed she has read a wide range of black feminist work; nothing in her comments or bibliography suggests that she has), she could have affirmed that appreciation without denigrating other black feminist critics. This cavalier treatment reminds me of the way the tokenism of black women in feminist scholarship and professional encounters takes on

dehumanizing forms. Black women are treated as though we are a box of chocolates presented to individual white women for their eating pleasure, so that they can decide for themselves and others which pieces are most tasty.

Ironically, even though Fuss praises the work of Carby and Spillers, it is not their work that is given extensive critical reading in this chapter. Indeed, she treats black women's subjectivity as a secondary issue. Such scholarship is permissible in an academic context that consistently marginalizes black women critics. I am always amazed by the complete absence of references to work by black women in contemporary critical works claiming to address in an inclusive way issues of gender, race, feminism, postcolonialism, and so on. Confronting colleagues about such absences, I, along with other black women critics, am often told that they were simply unaware that such material exists, that they were often working from their knowledge of available sources. Reading *Essentially Speaking*, I assumed Diana Fuss is either unfamiliar with the growing body of work by black feminist critics—particularly literary criticism—or that she excludes that work because she considers it unimportant. Clearly, she bases her assessment on the work she knows, rooting her analysis in experience. In the concluding chapter to her book, Fuss particularly criticizes using experience in the classroom as a base from which to espouse totalizing truths. Many of the limitations she points out could be easily applied to the way experience informs not only what we write about, but how we write about it, the judgments we make.

More than any other chapter in *Essentially Speaking*, this concluding essay is profoundly disturbing. It also undermines Fuss' previous insightful discussion of essentialism. Just as my experience of critical writing by black feminist thinkers would lead me to make different and certainly more complex assessments from those Fuss makes, my response to the chapter "Essentialism in the Classroom" is to some extent informed by

my different pedagogical experiences. This chapter provided me with a text I could engage dialectically; it served as a catalyst for clarifying my thoughts on essentialism in the classroom.

According to Fuss, issues of "essence, identity, and experience" erupt in the classroom primarily because of the critical input from marginalized groups. Throughout her chapter, whenever she offers an example of individuals who use essentialist standpoints to dominate discussion, to silence others via their invocation of the "authority of experience," they are members of groups who historically have been and are oppressed and exploited in this society. Fuss does not address how systems of domination already at work in the academy and the classroom silence the voices of individuals from marginalized groups and give space only when on the basis of experience it is demanded. She does not suggest that the very discursive practices that allow for the assertion of the "authority of experience" have already been determined by a politics of race, sex, and class domination. Fuss does not aggressively suggest that dominant groups—men, white people, heterosexuals—perpetuate essentialism. In her narrative it is always a marginal "other" who is essentialist. Yet the politics of essentialist exclusion as a means of asserting presence, identity, is a cultural practice that does not emerge solely from marginalized groups. And when those groups do employ essentialism as a way to dominate in institutional settings, they are often imitating paradigms for asserting subjectivity that are part of the controlling apparatus in structures of domination. Certainly many white male students have brought to my classroom an insistence on the authority of experience, one that enables them to feel that anything they have to say is worth hearing, that indeed their ideas and experience should be the central focus of classroom discussion. The politics of race and gender within white supremacist patriarchy grants them this "authority" without their having to name the desire for it. They do not attend class

and say, "I think that I am superior intellectually to my class-mates because I am white and male and that my experiences are much more important than any other group's." And yet their behavior often announces this way of thinking about identity, essence, subjectivity.

Why does Fuss's chapter ignore the subtle and overt ways essentialism is expressed from a location of privilege? Why does she primarily critique the misuses of essentialism by centering her analysis on marginalized groups? Doing so makes them the culprits for disrupting the classroom and making it an "unsafe" place. Is this not a conventional way the colonizer speaks of the colonized, the oppressor of the oppressed? Fuss asserts, "Prob-lems often begin in the classroom when those 'in the know' commerce only with others 'in the know,' excluding and mar-ginalizing those perceived to be outside the magic circle." This observation, which could certainly apply to any group, prefaces a focus on critical commentary by Edward Said that reinforces her critique of the dangers of essentialism. He appears in the text as resident "Third World authority" legitimating her argu-ment. Critically echoing Said, Fuss comments: "For Said it is both dangerous and misleading to base an identity politics upon rigid theories of exclusions, 'exclusions that stipulate, for instance, only women can understand feminine experience, only Jews can understand Jewish suffering, only formerly colo-nial subjects can understand colonial experience.'" I agree with Said's critique, but I reiterate that while I, too, critique the use of essentialism and identity politics as a strategy for exclu-sion or domination, I am suspicious when theories call this practice harmful as a way of suggesting that it is a strategy only marginalized groups employ. My suspicion is rooted in the awareness that a critique of essentialism that challenges only marginalized groups to interrogate their use of identity politics or an essentialist standpoint as a means of exerting coercive power leaves unquestioned the critical practices of other

[handwritten margin note: e.g. the faculty concerns expressed in the A.W. case]

groups who employ the same strategies in different ways and whose exclusionary behavior may be firmly buttressed by institutionalized structures of domination that do not critique or check it. At the same time, I am concerned that critiques of identity politics not serve as the new, chic way to silence students from marginal groups.

Fuss makes the point that "the artificial boundary between insider and outsider necessarily contains rather than disseminates knowledge." While I share this perception, I am disturbed that she never acknowledges that racism, sexism, and class elitism shape the structure of classrooms, creating a lived reality of insider versus outsider that is predetermined, often in place before any class discussion begins. There is rarely any need for marginalized groups to bring this binary opposition into the classroom because it is usually already operating. They may simply use it in the service of their concerns. Looked at from a sympathetic standpoint, the assertion of an excluding essentialism on the part of students from marginalized groups can be a strategic response to domination and to colonization, a survival strategy that may indeed inhibit discussion even as it rescues those students from negation. Fuss argues that "it is the unspoken law of the classroom not to trust those who cannot cite experience as the indisputable grounds of their knowledge. Such unwritten laws pose perhaps the most serious threat to classroom dynamics in that they breed suspicion amongst those inside the circle and guilt (sometimes anger) amongst those outside the circle." Yet she does not discuss who makes these laws, who determines classroom dynamics. Does she perhaps assert her authority in a manner that unwittingly sets up a competitive dynamic by suggesting that the classroom *belongs* more to the professor than to the students, to some students more than others?

As a teacher, I recognize that students from marginalized groups enter classrooms within institutions where their voices

have been neither heard nor welcomed, whether these students discuss facts—those which any of us might know—or personal experience. My pedagogy has been shaped to respond to this reality. If I do not wish to see these students use the "authority of experience" as a means of asserting voice, I can circumvent this possible misuse of power by bringing to the classroom pedagogical strategies that affirm their presence, their right to speak, in multiple ways on diverse topics. This pedagogical strategy is rooted in the assumption that we all bring to the classroom experiential knowledge, that this knowledge can indeed enhance our learning experience. If experience is already invoked in the classroom as a way of knowing that coexists in a nonhierarchical way with other ways of knowing, then it lessens the possibility that it can be used to silence. When I teach Toni Morrison's *The Bluest Eye* in introductory courses on black women writers, I assign students to write an autobiographical paragraph about an early racial memory. Each person reads that paragraph aloud to the class. Our collective listening to one another affirms the value and uniqueness of each voice. This exercise highlights experience without privileging the voices of students from any particular group. It helps create a communal awareness of the diversity of our experiences and provides a limited sense of the experiences that may inform how we think and what we say. Since this exercise makes the classroom a space where experience is valued, not negated or deemed meaningless, students seem less inclined to make the telling of experience that site where they compete for voice, if indeed such a competition is taking place. In our classroom, students do not usually feel the need to compete because the concept of a privileged voice of authority is deconstructed by our collective critical practice.

In the chapter "Essentialism in the Classroom" Fuss centers her discussion on locating a particular voice of authority. Here it is her voice. When she raises the question "how are we to han-

dle" students, her use of the word "handle" suggests images of manipulation. And her use of a collective "we" implies a sense of a unified pedagogical practice shared by other professors. In the institutions where I have taught, the prevailing pedagogical model is authoritarian, hierarchical in a coercive and often dominating way, and certainly one where the voice of the professor is the "privileged" transmitter of knowledge. Usually these professors devalue including personal experience in classroom discussion. Fuss admits to being wary of attempts to censor the telling of personal histories in the classroom on the basis that they have not been "adequately 'theorized'," but she indicates throughout this chapter that on a fundamental level she does not believe that the sharing of personal experience can be a meaningful addition to classroom discussions. If this bias informs her pedagogy, it is not surprising that invocations of experience are used aggressively to assert a privileged way of knowing, whether against her or other students. If a professor's pedagogy is not liberatory, then students will probably not compete for value and voice in the classroom. That essentialist standpoints are used competitively does not mean that the taking of those positions creates the situation of conflict.

Fuss's experiences in the classroom may reflect the way in which "competition for voice" is an integral part of her pedagogical practice. Most of the comments and observations she makes about essentialism in the classroom are based on her experience (and perhaps that of her colleagues, though this is not explicit). Based on that experience she can confidently assert that she "remain[s] convinced that appeals to the authority of experience rarely advance discussion and frequently provoke confusion." To emphasize this point further she says, "I am always struck by the way in which introjections of experiential truths into classroom debates dead-end the discussion." Fuss draws on her particular experience to make totalizing generalizations. Like her, I have seen the way essentialist stand-

points can be used to silence or assert authority over the oppo-
sition, but I most often see and experience the way the telling
of personal experience is incorporated into classrooms in ways
that deepen discussion. And I am most thrilled when the tell-
ing of experience links discussions of facts or more abstract
constructs to concrete reality. My experience in the classroom
may be different from Fuss's because I speak as an institution-
ally marginalized other, and here I do not mean to assume an
essentialist position. There are many black women professors
who would not claim this location. The majority of students
who enter our classrooms have never been taught by black
women professors. My pedagogy is informed by this knowl-
edge, because I know from experience that this unfamiliarity
can overdetermine what takes place in the classroom. Also,
knowing from personal experience as a student in predomi-
nantly white institutions how easy it is to feel shut out or closed
down, I am particularly eager to help create a learning process
in the classroom that engages everyone. Therefore, biases
imposed by essentialist standpoints or identity politics, along-
side those perspectives that insist that experience has no place
in the classroom (both stances can create an atmosphere of
coercion and exclusion), must be interrogated by pedagogical
practices. Pedagogical strategies can determine the extent to
which all students learn to engage more fully the ideas and
issues that seem to have no direct relation to their experience.

Fuss does not suggest that teachers who are aware of the
multiple ways essentialist standpoints can be used to shut down
discussion can construct a pedagogy that critically intervenes
before one group attempts to silence another. Professors, espe-
cially those from dominant groups, may themselves employ
essentialist notions to constrain the voices of particular stu-
dents; hence we must all be ever-vigilant in our pedagogical
practices. Whenever students share with me the sense that my
pedagogical practices are silencing them, I have to examine

[handwritten margin note: we DO need to be careful in the classroom]

that process critically. Even though Fuss grudgingly acknowledges that the telling of experience in the classroom may have some positive implications, her admission is quite patronizing:

> while truth clearly does not equate with experience, it cannot be denied that it is precisely the fiction that they are the same which prompts many students, who would not perhaps speak otherwise, to enter energetically into those debates they perceive as pertaining directly to them. The authority of experience, in other words, not only works to silence students, it also works to empower them. How are we to negotiate the gap between the conservative fiction of experience as the ground of all truth-knowledge and the immense power of this fiction to enable and encourage student participation?

All students, not just those from marginalized groups, seem more eager to enter energetically into classroom discussion when they perceive it as pertaining directly to them (when nonwhite students talk in class only when they feel connected via experience it is not aberrant behavior). Students may be well versed in a particular subject and yet be more inclined to speak confidently if that subject directly relates to their experience. Again, it must be remembered that there are students who may not feel the need to acknowledge that their enthusiastic participation is sparked by the connection of that discussion to personal experience.

In the introductory paragraph to "Essentialism in the Classroom" Fuss asks, "Exactly what counts as 'experience,' and should we defer to it in pedagogical situations?" Framing the question in this way makes it appear that comments about experiences necessarily disrupt the classroom, engaging the professor and students in a struggle for authority that can be mediated if the professor defers. This question, however, could be posed in a manner that would not imply a condescending

devaluation of experience. We might ask: How can professors
and students who want to share personal experience in the
classroom do so without promoting essentialist standpoints
that exclude? Often when professors affirm the importance of
experience students feel less need to insist that it is a privileged
way of knowing. Henry Giroux, in his writing on critical peda-
gogy, suggests that "the notion of experience has to be situated
within a theory of learning." Giroux suggests that professors
must learn to respect the way students feel about their experi-
ences as well as their need to speak about them in classroom
settings: "You can't deny that students have experiences and
you can't deny that these experiences are relevant to the learn-
ing process even though you might say these experiences are
limited, raw, unfruitful or whatever. Students have memories,
families, religions. feelings, languages and cultures that give
them a distinctive voice. We can critically engage that experi-
ence and we can move beyond it. But we can't deny it." Usually
it is in a context where the experiential knowledge of students
is being denied or negated that they may feel most determined
to impress upon listeners both its value and its superiority to
other ways of knowing.

[margin note: both theory and experience]

Unlike Fuss, I have not been in classrooms where students
find "empirical ways of knowing analytically suspect." I have
taught feminist theory classes where students express rage
against work that does not clarify its relationship to concrete
experience, that does not engage feminist praxis in an intelligi-
ble way. Student frustration is directed against the inability of
methodology, analysis, and abstract writing (usually blamed on
the material and often justifiably so) to make the work connect
to their efforts to live more fully, to transform society, to live a
politics of feminism.

[margin note: isn't this the purpose of theory?]

Identity politics emerges out of the struggles of oppressed
or exploited groups to have a standpoint on which to critique
dominant structures, a position that gives purpose and mean-

ing to struggle. Critical pedagogies of liberation respond to these concerns and necessarily embrace experience, confessions and testimony as relevant ways of knowing, as important, vital dimensions of any learning process. Skeptically, Fuss asks, "Does experience of oppression confer special jurisdiction over the right to speak about that oppression?" This is a question that she does not answer. Were it posed to me by students in the classroom, I would ask them to consider whether there is any "special" knowledge to be acquired by hearing oppressed individuals speak from their experience—whether it be of victimization or resistance—that might make one want to create a privileged space for such discussion. Then we might explore ways individuals acquire knowledge about an experience they have not lived, asking ourselves what moral questions are raised when they speak for or about a reality that they do not know experientially, especially if they are speaking about an oppressed group. In classrooms that have been extremely diverse, where I have endeavored to teach material about exploited groups who are not black, I have suggested that if I bring to the class only analytical ways of knowing and someone else brings personal experience, I welcome that knowledge because it will enhance our learning. Also, I share with the class my conviction that if my knowledge is limited, and if someone else brings a combination of facts and experience, then I humble myself and respectfully learn from those who bring this great gift. I can do this without negating the position of authority professors have, since fundamentally I believe that combining the analytical and experiential is a richer way of knowing.

Years ago, I was thankful to discover the phrase "the authority of experience" in feminist writing because it gave me a name for what I brought to feminist classrooms that I thought was not present but believed was valuable. As an undergraduate in feminist classrooms where woman's experience was universalized, I knew from my experience as a black female that black

women's reality was being excluded. I spoke from that knowl-
edge. There was no body of theory to invoke that would sub-
stantiate this truth claim. No one really wanted to hear about
the deconstruction of woman as a category of analysis then.
Insisting on the value of my experience was crucial to gaining a
hearing. Certainly, the need to understand my experience
motivated me as an undergraduate to write *Ain't I a Woman:
Black Women and Feminism.*

Now I am troubled by the term "authority of experience,"
acutely aware of the way it is used to silence and exclude. Yet I
want to have a phrase that affirms the specialness of those ways
of knowing rooted in experience. I know that experience can
be a way to know and can inform how we know what we know.
Though opposed to any essentialist practice that constructs
identity in a monolithic, exclusionary way, I do not want to
relinquish the power of experience as a standpoint on which to
base analysis or formulate theory. For example, I am disturbed
when all the courses on black history or literature at some col-
leges and universities are taught solely by white people, not
because I think that they cannot know these realities but that
they know them differently. Truthfully, if I had been given the
opportunity to study African American critical thought from a
progressive black professor instead of the progressive white
woman with whom I studied as a first-year student, I would have
chosen the black person. Although I learned a great deal from
this white woman professor, I sincerely believe that I would
have learned even more from a progressive black professor,
because this individual would have brought to the class that
unique mixture of experiential and analytical ways of know-
ing—that is, a privileged standpoint. It cannot be acquired
through books or even distanced observation and study of a
particular reality. To me this privileged standpoint does not
emerge from the "authority of experience" but rather from the
passion of experience, the passion of remembrance.

Often experience enters the classroom from the location of memory. Usually narratives of experience are told retrospectively. In the testimony of Guatemalan peasant and activist Rigoberta Menchú, I hear the passion of remembrance in her words:

> My mother used to say that through her life, through her living testimony, she tried to tell women that they too had to participate, so that when the repression comes and with it a lot of suffering, it's not only the men who suffer. Women must join the struggle in their own way. My mother's words told them that any evolution, any change, in which women had not participated, would not be change, and there would be no victory. She was as clear about this as if she were a woman with all sorts of theories and a lot of practice.

I know that I can take this knowledge and transmit the message of her words. Their meaning could be easily conveyed. What would be lost in the transmission is the spirit that orders those words, that testifies that, behind them—underneath, every where—there is a lived reality. When I use the phrase "passion of experience," it encompasses many feelings but particularly suffering, for there is a particular knowledge that comes from suffering. It is a way of knowing that is often expressed through the body, what it knows, what has been deeply inscribed on it through experience. This complexity of experience can rarely be voiced and named from a distance. It is a privileged location, even as it is not the only or even always the most important location from which one can know. In the classroom, I share as much as possible the need for critical thinkers to engage multiple locations, to address diverse standpoints, to allow us to gather knowledge fully and inclusively. Sometimes, I tell students, it is like a recipe. I tell them to imagine we are baking bread that needs flour. And we have all the other ingredients but no flour. Suddenly, the flour becomes

most important even though it alone will not do. This is a way to think about experience in the classroom.

On another day, I might ask students to ponder what we want to make happen in the class, to name what we hope to know, what might be most useful. I ask them what standpoint is a personal experience. Then there are times when personal experience keeps us from reaching the mountaintop and so we let it go because the weight of it is too heavy. And sometimes the mountaintop is difficult to reach with all our resources, factual and confessional, so we are just there collectively grasping, feeling the limitations of knowledge, longing together, yearning for a way to reach that highest point. Even this yearning is a way to know.

7

Holding My Sister's Hand

Feminist Solidarity

"Feminism must be on the cutting edge of real social change if it is to survive as a movement in any particular country."

—Audre Lorde, *A Burst of Light*

"We are the victims of our History and our Present. They place too many obstacles in the Way of Love. And we cannot enjoy even our differences in peace."

—Ama Ata Aidoo, *Our Sister Killjoy*

Patriarchal perspectives on race relations have traditionally evoked the image of black men gaining the freedom to be sexual with white women as that personal relationship which best exemplifies the connection between public struggle for racial equality and the private politics of racial intimacy. Racist fears that socially sanctioned romantic relationships between black

men and white women would dismantle the white patriarchal family structure historically heightened the sense of taboo, even as individuals chose to transgress boundaries. But sex between black men and white women, even when legally sanctioned through marriage, did not have the feared impact. It did not fundamentally threaten white patriarchy. It did not further the struggle to end racism. Making heterosexual sexual experience—particularly the issue of black men gaining access to the bodies of white women—the quintessential expression of racial liberation deflected attention away from the significance of social relations between white and black women, and of the ways this contact determines and affects race relations.

As a teenager in the late sixties, living in a racially segregated Southern town, I knew that black men who desired intimacy with white women, and vice versa, forged bonds. I knew of no intimacy, no deep closeness, no friendship between black and white women. Though never discussed, it was evident in daily life that definite barriers separated the two groups, making close friendship impossible. The point of contact between black women and white women was one of servant-served, a hierarchal, power-based relationship unmediated by sexual desire. Black women were the servants, and white women were the served.

In those days, a poor white woman who might never be in a position to hire a black woman servant would still, in all her encounters with black women, assert a dominating presence, ensuring that contact between the two groups should always place white in a position of power over black. The servant-served relationship was established in domestic space, in the household, within a context of familiarity and commonality (the belief that it was the female's role to tend the home was shared by white and black women). Given this similarity of positioning within sexist norms, personal contact between the two

groups was carefully constructed to reinforce difference in status based on race. Recognizing class difference was not enough of a division; white women wanted their racial status affirmed. They devised strategies both subtle and overt to reinforce racial difference, to assert their superior positions. This was especially the case in households where white women remained home during the day while black female servants worked. White women might talk about "niggers" or enact ritualized scenarios focusing on race in order to stress differentiation in status. Even a small gesture—like showing a black servant a new dress that she would not be able to try on in a store because of Jim Crow laws—reminded all concerned of the difference in status based on race.

Historically, white female efforts to maintain racial dominance were directly connected to the politics of heterosexism within a white supremacist patriarchy. Sexist norms, which deemed white women inferior because of gender, could be mediated by racial bonding. Even though males, white and black, may have been most concerned with policing or gaining access to white women's bodies, the social reality white women lived was one in which white males did actively engage in sexual relationships with black women. In the minds of most white women, it was not important that the overwhelming majority of these liaisons were forged by aggressive coercion, rape, and other forms of sexual assault; white women saw black women as competitors in the sexual marketplace. Within a cultural setting where a white woman's status was overdetermined by her relationship to white men, it follows that white women desired to maintain clear separations between their status and that of black women. It was crucial that black women be kept at a distance, that racial taboos forbidding legal relations between the two groups be reinforced either by law or social opinion. (In those rare cases where slaveholding white men sought divorces

to legitimate liaisons with black slave women, they were most often judged insane.) In a white supremacist patriarchy, that relationship which most threatened to disrupt, challenge, and dismantle white power its concomitant social order was the legalized union between a white man and a black woman. Slave testimony, as well as the diaries of southern white women, record incidents of jealousy, rivalry, and sexual competition between white mistresses and enslaved black women. Court records document that individual white men did try to gain public recognition of their bonds with black women either through attempts to marry or through efforts to leave property and money in wills. Most of these cases were contested by white family members. Importantly, white females were protecting their fragile social positions and power within patriarchal culture by asserting their superiority over black women. They were not necessarily trying to prevent white men from engaging in sexual relations with black women, for this was not in their power— such is the nature of patriarchy. So long as sexual unions with black women and white men took place in a nonlegalized context, within a framework of subjugation, coercion, and degradation, the split between white female's status as "ladies" and black women's representation as "whores" could be maintained. Thus to some extent, white women's class and race privilege was reinforced by the maintenance of a system where black women were the objects of white male sexual subjugation and abuse.

Contemporary discussions of the historical relationship between white and black women must include acknowledgment of the bitterness black slave women felt towards white women. They harbored understandable resentment and repressed rage about racial oppression, but they were particularly aggrieved by the overwhelming absence of sympathy shown by white women in circumstances involving sexual and physical abuse of black women as well as situations where black children were taken away from their enslaved mothers. Again it was within this

realm of shared concern (white women knew the horror of sexual and physical abuse as well as the depth of a mother's attachment to her children) that the majority of white women who might have experienced empathic identification turned their backs on black women's pain.

Shared understanding of particular female experiences did not mediate relations between most white mistresses and black slave women. Though there were rare exceptions, they had little impact on the overall structure of relations between black and white women. Despite the brutal oppression of black female slaves, many white women feared them. They may have believed that, more than anything, black women wanted to change places with them, to acquire their social status, to marry their men. And they must have feared (given white male obsessions with black women) that, were there no legal and social taboos forbidding legalized relations, they would lose their status.

The abolition of slavery had little meaningful positive impact on relations between white and black women. Without the structure of slavery, which institutionalized, in a fundamental way, the different status of white and black women, white women were all the more concerned that social taboos uphold their racial superiority and forbid legalized relations between the races. They were instrumental in perpetuating degrading stereotypes about black womanhood. Many of these stereotypes reinforced the notion that black women were lewd, immoral, sexually licentious, and lacking in intelligence. White women had a closeness with black women in the domestic household that made it appear that they knew what we were really like; they had direct contact. Though there is little published material from the early twentieth century documenting white female perceptions of black women and vice versa, segregation diminished the possibility that the two groups might develop a new basis of contact with one another outside the realm of servant-served. Living in segregated neighborhoods,

there was little chance that white and black women would meet one another on common, neutral ground.

The black woman who traveled from her segregated neighborhood into "unsafe" white areas, to work in the homes of white families, no longer had a set of familial relations, however tenuous, that were visible and known by white women employers as had been the case under slavery. The new social arrangement was as much a context for dehumanization as the plantation household, with the one relief that black women could return home. Within the social circumstance of slavery, white mistresses were sometimes compelled by circumstance, caring feelings, or concern for property to enter the black female's place of residence and be cognizant of a realm of experience beyond the servant-served sphere. This was not the case with the white female employer.

Racially segregated neighborhoods (which were the norm in most cities and rural areas) meant that black women left poor neighborhoods to work in privileged white homes. There was little or no chance that this circumstance would promote and encourage friendship between the two groups. White women continued to see black women as sexual competitors, ignoring white male sexual assault and abuse of black females. Although they have written poignant memoirs which describe affectional bonds between themselves and black female servants, white women often failed to acknowledge that intimacy and care can coexist with domination. It has been difficult for white women who perceive black women servants to be "like one of the family" to understand that the servant might have a completely different understanding of their relationship. The servant may be ever mindful that no degree of affection or care altered differences in status—or the reality that white women exercised power, whether benevolently or tyrannically.

Much of the current scholarship by white women focusing on relationships between black women domestics and white

female employers presents perspectives that highlight posi-
tives, obscuring the ways negative interaction in these settings
have created profound mistrust and hostility between the two
groups. Black female servants interviewed by white women
often give the impression that their relationships with white
women employers had many positive dimensions. They say
what they feel is the polite and correct version of reality, often
suppressing truths. Again it must be remembered that ex-
ploitative situations can also be settings where caring ties
emerge even in the face of domination (feminists should know
this from the evidence that care exists in heterosexual rela-
tionships where men abuse women). Hearing Susan Tucker
give an oral presentation discussing her book *Telling Memories
Among Southern Women: Domestic Workers Employers in the Seg-
regated South,* I was struck by her willingness to acknowledge
that as a white child cared for by black women she remem-
bered overhearing them expressing negative feelings about
white women. She was shocked by their expressions of rage,
enmity, and contempt. We both remembered a common dec-
laration of black women: "I've never met a white woman over
the age of twelve that I can respect." In contrast to her memo-
ries, Tucker's contemporary discussion paints a much more
positive picture of the subject. Studies of black and white
women's relationships must cease to focus solely on whether
interaction between black servants and white female employ-
ers was "positive." If we are to understand our contemporary
relations, we must explore the impact of those encounters on
black women's perceptions of white women as a whole. Many
of us who have never been white women's servants have inher-
ited ideas about them from relatives and kin, ideas which
shape our expectations and interactions.

My memories and present day awareness (based on conver-
sations with my mother, who works as a maid for white women,
and the comments and stories of black women in our commu-

nities) indicate that in "safe" settings black women highlight
the negative aspects of working as servants for white women.
They express intense anger, hostility, bitterness, and envy—and
very little affection or care—even when they are speaking posi-
tively. Many of these women recognize the exploitative nature
of their jobs, identifying ways they are subjected to various
unnecessary humiliations and degrading encounters. This rec-
ognition may be the most salient feature in a situation where a
black woman may also have good feelings about her white
employer (Judith Rollins's book, *Between Women*, is a useful and
insightful discussion of these relationships).

Whether talking with black domestics or nonprofessional
black women, I find that the overwhelming perceptions of
white women are negative. Many of the black women who have
worked as servants in white homes, particularly during the
times when white women were not gainfully employed, see
white women as maintaining childlike, self-centered postures of
innocence and irresponsibility at the expense of black women.
Again and again, it was pointed out that the degree to which
white women are able to turn away from domestic reality, from
the responsibilities of child care and housework, whether they
are turning away for careers or to have greater leisure, is deter-
mined by the extent to which black women, or some other
underclass group, are bound to that labor, forced by economic
circumstance to pick up the slack, to assume responsibility.

I found it ironic that black women often critiqued white
women from a nonfeminist standpoint, emphasizing the ways
in which white women were not worthy of being on pedestals
because they were shiftless, lazy, and irresponsible. Some black
women seemed to feel a particular rage that their work was
"overseen" by white women whom they saw as ineffectual and
incapable of performing the very tasks they were presiding
over. Black women working as servants in white homes were in
positions similar to those assumed by cultural anthropologists

seeking to understand a different culture. From this particular insider vantage point, black women learned about white life-styles. They observed all the details in white households, from furnishings to personal encounters. Taking mental notes, they make judgments about the quality of life they witnessed, comparing it to black experience. Within the confines of segregated black communities, they shared their perceptions of the white "other." Often their accounts were most negative when they described white women; they were able to study them much more consistently than white men, who were not always present. If the racist white world represented black women as sluts, then black women examined the actions of white women to see if their sexual mores were different. Their observations often contradicted stereotypes. Overall, black women have come away from encounters with white women in the servant-served relationship feeling confident that the two groups are radically different and share no common language. It is this legacy of attitudes and reflections about white women that is shared from generation to generation, keeping alive the sense of distance and separation, feelings of suspicion and mistrust. Now that interracial relationships between whites and blacks are more common, black women see white women as sexual competitors—irrespective of sexual preference—often advocating continued separation in the private sphere despite proximity and closeness in work settings.

Contemporary discussions of relationships between black women and white women (whether scholarly or personal) rarely take place in integrated settings. White women writing about their impressions in scholarly and confessional work often ignore the depth of enmity between the two groups, or see it as solely a black female problem. Many times in feminist circles I have heard white women talk about a particular black woman's hostility toward white females as though such feelings are not rooted in historical relations and contemporary inter-

actions. Instead of exploring the reasons such hostility exists, or giving it any legitimacy as an appropriate response to domination or exploitation, they see the black woman as being difficult, problematic, irrational, and "insane." Until white women can confront their fear and hatred of black women (and vice versa), until we can acknowledge the negative history which shapes and informs our contemporary interaction, there can be no honest, meaningful dialogue between the two groups. The contemporary feminist call for sisterhood, the radical white woman's appeal to black women and all women of color to join the feminist movement, is seen by many black women as yet another expression of white female denial of the reality of racist domination, of their complicity in the exploitation and oppression of black women and black people. Though the call for sisterhood was often motivated by a sincere longing to transform the present, expressing white female desire to create a new context for bonding, there was no attempt to acknowledge history, or the barriers that might make such bonding difficult, if not impossible. When black women responded to the evocation of sisterhood based on shared experience by calling attention to both the past of racial domination and its present manifestations in the structure of feminist theory and the feminist movement, white women initially resisted the analysis. They assumed a posture of innocence and denial (a response that evoked memories in black women of negative encounters, the servant-served relationship). Despite flaws and contradictions in her analysis, Adrienne Rich's essay "'Disloyal to Civilization': Feminism, Racism, and Gynephobia" was groundbreaking in that it ruptured that wall of denial, addressing the issue of race and accountability. White women were more willing to "hear" another white woman talk about racism, yet it is their inability to listen to black women that impedes feminist progress.

Ironically, many of the black women who were actively en-

gaged with feminist movement were talking about racism in a sincere attempt to create an inclusive movement, one that would bring white and black women together. We believed that true sisterhood would not emerge without radical confrontation, without feminist exploration and discussion of white female racism and black female response. Our desire for an honorable sisterhood, one that would emerge from the willingness of all women to face our histories, was often ignored. Most white women dismissed us as "too angry," refusing to reflect critically on the issues raised. By the time white women active in the feminist movement were willing to acknowledge racism, accountability, and its impact on the relationships between white women and women of color, many black women were devastated and worn out. We felt betrayed; white women had not fulfilled the promise of sisterhood. That sense of betrayal continues and is intensified by the apparent abdication of interest in forging sisterhood, even though white women now show interest in racial issues. It seems at times as though white feminists working in the academy have appropriated discussions of race and racism, while abandoning the effort to construct a space for sisterhood, a space where they could examine and change attitudes and behavior towards black women and all women of color.

With the increasing institutionalization and professionalization of feminist work focused on the construction of feminist theory and the dissemination of feminist knowledge, white women have assumed positions of power that enable them to reproduce the servant-served paradigm in a radically different context. Now black women are placed in the position of serving white female desire to know more about race and racism, to "master" the subject. Curiously, most white women writing feminist theory that looks at "difference" and "diversity" do not make white women's lives, works, and experiences the subject of their analysis of "race," but rather focus on black women or

women of color. White women who have yet to get a critical handle on the meaning of "whiteness" in their lives, the representation of whiteness in their literature, or the white supremacy that shapes their social status are now explicating blackness without critically questioning whether their work emerges from an aware antiracist standpoint. Drawing on the work of black women, work that they once dismissed as irrelevant, they now reproduce the servant-served paradigms in their scholarship. Armed with their new knowledge of race, their willingness to say that their work is coming from a white perspective (usually without explaining what that means), they forget that the very focus on race and racism emerged from the concrete political effort to forge meaningful ties between women of different race and class groups. This struggle is often completely ignored. Content with the appearance of greater receptivity (the production of texts where white women discuss race is given as evidence that there has been a radical shift in direction), white women ignore the relative absence of black women's voices, either in the construction of new feminist theory or at feminist gatherings.

Talking with groups of women about whether they thought feminist movement has had a transformative impact on relations between white and black women, I heard radically different responses. Most white women felt there had been a change, that they were more aware of race and racism, more willing to assume accountability and engage in antiracist work. Black women and women of color were adamant that little had changed, that despite recent white female focus on race, racist domination is still a factor in personal encounters. They felt that the majority of white women still assert power even as they address issues of race. As one black woman put it, "It burns me up to be treated like shit by white women who are busy getting their academic recognition, promotions, more money, et cetera, doing 'great' work on the topic of race." Some black

women I spoke with suggested that it was fear that their re-
sources would be appropriated by white women that led them
to avoid participating in feminist movement.

Fear and anger about appropriation, as well as concern that
we not be complicit in reproducing servant-served relation-
ships, have led black women to withdraw from feminist settings
where we must have extensive contact with white women. With-
drawal exacerbates the problem: it makes us complicit in a differ-
ent way. If a journal is doing a special issue on Black Women's
Studies and only white women submit work, then black women
cannot effectively challenge their hegemonic hold on feminist
theory. This is only one example of many. Without our voices
in written work and in oral presentations there will be no artic-
ulation of our concerns. Where are our books on race and
feminism and other aspects of feminist theory, works which
offer new approaches and understanding? What do we do to
further the development of a more inclusive feminist theory
and practice? What do we presume our role to be in the map-
ping of future direction for feminist movement? Withdrawal is
not the answer.

Even though practically every black woman active in any
aspect of feminist movement has a long record of horror sto-
ries documenting the insensitivity and racist aggression of indi-
vidual white women, we can testify as well to those encounters
that are positive, that enrich rather than diminish. Granted,
such encounters are rare. They tend to take place with white
women who are not in positions where they can assert power
(which may be why these are seen as exceptional rather than as
positive signs indicating the overall potential for growth and
change, for greater togetherness). Perhaps we need to exam-
ine the degree to which white women (and all women) who
assume powerful positions rely on conventional paradigms of
domination to reinforce and maintain that power.

Talking with black women and women of color I wanted to

know what factors distinguish these relationships we have with white feminists which we do not see as exploitative or oppressive. A common response was that these relationships had two important factors: honest confrontation, and dialogue about race, and reciprocal interaction. Within the servant-served paradigm, it is usually white women who are seeking to receive something from black women, even if that something is knowledge about racism. When I asked individual white women who have friendships and positive work relations with black women in feminist settings what were the conditions enabling reciprocity, they responded by emphasizing that they had not relied on black women to force them to confront their racism. Somehow, assuming responsibility for examining their own responses to race was a precondition for relations on an equal footing. These women felt they approach women of color with knowledge about racism, not with guilt, shame, or fear. One white woman said that she starts from the standpoint of accepting and acknowledging that "white people always have racist assumptions that we have to deal with." Readiness to deal with these assumptions certainly makes forming ties with nonwhite women easier. She suggests that the degree to which a white woman can accept the truth of racist oppression—of white female complicity, of the privileges white women receive in a racist structure—determines the extent to which they can be empathic with women of color. In conversations I found that feminist white women from nonmaterially privileged backgrounds often felt their understanding of class difference made it easier for them to hear women of color talk about the impact of race, of domination, without feeling threatened. Personally, I find many of my deepest friendships and feminist bonds are formed with white women who come from working class backgrounds or who are working class and understand the impact of poverty and deprivation.

I talked about writing this essay with a group of white female colleagues—all of them English professors—and they emphasized the fear many privileged white women have of black women. We all remembered Lillian Hellman's frank comments about her relationship with the black woman servant who was in her employ for many years. Hellman felt that this woman really exercised enormous power over her, admitting that it made her fear all black women. We talked about the fact that what many white women fear is being unmasked by black women. One white woman, from a working-class background, pointed out that black women servants witnessed the gap between white women's words and their deeds, saw contradictions and inadequacies. Perhaps contemporary generations of white women who do not have black servants, who never will, have inherited from their female ancestors the fear that black women have the power to see through their disguises, to see the parts of themselves they want no one to see. Though most of the white women present at this discussion do not have close friendships with black women, they would welcome the opportunity to have more intimate contact. Often black women do not respond to friendly overtures by white women for fear that they will be betrayed, that at some unpredictable moment the white woman will assert power. This fear of betrayal is linked with white female fear of exposure; clearly we need feminist psychoanalytic work that examines these feelings and the relational dynamics they produce.

Often black female fear of betrayal is not present when an individual white woman indicates by her actions that she is committed to antiracist work. For example, I once applied for a job in the Women's Studies program at a white women's college. The committee reviewing my application was all white. During the review process one of the reviewers felt that racism was shaping the nature and direction of the discussions, and

she intervened. One gesture of intervention she made was to
contact the black woman affirmative action officer so that
there would be nonwhite participation in the discussion. Her
commitment to feminist process and antiracist work informed
her actions. She extended herself even though there was no
personal gain. (Let's face it: opportunism has prevented many
academic feminists from taking action that would force them
to go against the status quo and take a stand.) Her actions con-
firmed for me both the power of solidarity and sisterhood. She
did not play it safe. To challenge, she had to separate herself
from the power and privilege of the group. One of the most
revealing insights she shared was her initial disbelief that white
feminists could be so blatantly racist, assuming that everyone in
the group shared a common bond in "whiteness," the common
acceptance that in an all-white group it was fine to talk about
black people in stereotypical racist ways. When this process
ended (I was offered the job), we talked about her sense that
what she witnessed was white female fear that in the presence
of black female power, their authority would be diminished.
We talked about ways feelings allow many white women to feel
more comfortable with black women who appear victimized or
needy. We focused on ways white feminists sometimes patron-
ize black women by assuming that it is understandable if we are
not "radical," if our work on gender does not have a feminist
standpoint. This condescension further estranges black and
white women. It is an expression of racism.

 Now that many white women engaged in feminist thinking
and practice no longer deny the impact of race on the con-
struction of gender identity, the oppressive aspects of racial
domination, and white female complicity, it is time to move on
to an exploration of the particular fears that inhibit meaning-
ful bonding with black women. It is time for us to create new
models for interaction that take us beyond the servant-served
encounter, ways of being that promote respect and reconcilia-

tion. Concurrently, black women need to explore our collective attachment to rage and hostility towards white women. It may be necessary for us to have spaces where some of that repressed anger and hostility can be openly expressed so that we can trace its roots, understand it, and examine possibilities for transforming internalized anger into constructive, self-affirming energy we can use effectively to resist white female domination and forge meaningful ties with white female allies. Only when our vision is clear will we be able to distinguish sincere gestures of solidarity from actions rooted in bad faith. It may very well be that some black female rage towards white women masks sorrow and pain, anguish that it has been so difficult to make contact, to impress upon their consciousness our subjectivity. Letting go of some of the hurt may create a space for courageous contact without fear or blame.

If black women and white women continue to express fear and rage without a commitment to move on through these emotions in order to explore new grounds for contact, our efforts to build an inclusive feminist movement will fail. Much depends on the strength of our commitment to feminist process and feminist movement. There have been so many feminist occasions where differences surface, and with them expressions of pain, rage, hostility. Rather than coping with these emotions and continuing to probe intellectually and search for insight and strategies of confrontation, all avenues for discussions become blocked and no dialogue occurs. I am confident that women have the skills (developed in interpersonal relations where we confront gender difference) to make productive space for critical dissent dialogue even as we express intense emotions. We need to examine why we suddenly lose the capacity to exercise skill and care when we confront one another across race and class differences. It may be that we give up so easily with one another because women have internalized the racist assumption that we can never overcome the barrier

separating white women and black women. If this is so then we are seriously complicit. To counter this complicity, we must have more written work and oral testimony documenting ways barriers are broken down, coalitions formed, and solidarity shared. It is this evidence that will renew our hope and provide strategies and direction for future feminist movement.

Producing this work is not the exclusive task of white or black women; it is collective work. The presence of racism in feminist settings does not exempt black women or women of color from actively participating in the effort to find ways to communicate, to exchange ideas, to have fierce debate. If revitalized feminist movement is to have a transformative impact on women, then creating a context where we can engage in open critical dialogue with one another, where we can debate and discuss without fear of emotional collapse, where we can hear and know one another in the difference and complexities of our experience, is essential. Collective feminist movement cannot go forward if this step is never taken. When we create this woman space where we can value difference and complexity, sisterhood based on political solidarity will emerge.

8

Feminist Thinking

In the Classroom Right Now

Teaching women's studies classes for more than ten years, I've seen exciting changes. Right now teachers and students face new challenges in the feminist classroom. Our students are no longer necessarily already committed to or interested in feminist politics (which means we are not just sharing the "good news" with the converted). They are no longer predominantly white or female. They are no longer solely citizens of the United States. When I was a young graduate student teaching feminist courses, I taught them in Black Studies. At that time, women's studies programs were not ready to accept a focus on race and gender. Any curriculum focusing specifically on black women was seen as "suspect," and no one was yet using the catch-all phrase "women of color." In those days, the students in my feminist classrooms were almost all black. They were fundamentally skeptical about the importance of feminist thinking or feminist movement to any discussion of race and racism, to any

analysis of black experience and black liberation struggle. Over
time, that skepticism has deepened. Black students, female and
male, continually interrogate this issue. Whether in the class-
room or while giving a public lecture, I am continually asked
whether or not black concern with the struggle to end racism
precludes involvement with feminist movement. "Don't you
think black women, as a race, are more oppressed than women?"
"Isn't the women's movement really for white women?" or
"Haven't black women always been liberated?" tend to be the
norm. Striving to answer questions like these has led to shifts in
my ways of thinking and writing. As a feminist teacher, theorist,
and activist, I am deeply committed to black liberation struggle
and want to play a major role in re-articulating the theoretical
politics of this movement so that the issue of gender will be
addressed, and feminist struggle to end sexism will be consid-
ered a necessary component of our revolutionary agenda.

Commitment to feminist politics and black liberation strug-
gle means that I must be able to confront issues of race and gen-
der in a black context, providing meaningful answers to
problematic questions as well as appropriate accessible ways to
communicate them. The feminist classroom and lecture hall
that I am speaking in most often today is rarely all black.
Though the politically progressive clamor is for "diversity,"
there is little realistic understanding of the ways feminist schol-
ars must change ways of seeing, talking, and thinking if we are to
speak to the various audiences, the "different" subjects who may
be present in one location. How many feminist scholars can
respond effectively when faced with a racially and ethnically
diverse audience who may not share similar class backgrounds,
language, levels of understanding, communication skills, and
concerns? As a black woman professor in the feminist classroom
teaching women's studies classes, these issues surface daily for
me. My joint appointment in English, African American Stud-
ies, and Women's Studies as well as other disciplines usually

means that I teach courses from a feminist standpoint, but that are not listed specifically as women's studies courses. Students may take a course on black women writers without expecting that the material will be approached from a feminist perspective. This is why I make a distinction between the feminist classroom and a Women's Studies course.

In a feminist classroom, especially a Women's Studies course, the black student, who has had no previous background in feminist studies, usually finds that she or he is in a class that is predominantly white (often attended by a majority of outspoken young, white, radical feminists, many of whom link this politic to issues of gay rights). Unfamiliarity with the issues may lead black students to feel at a disadvantage both academically and culturally (they may not be accustomed to public discussions of sexual practice). If a black student acknowledges that she is not familiar with the work of Audre Lorde and the rest of the class gasps as though this is unthinkable and reprehensible, that gasp evokes the sense that feminism is really a private cult whose members are usually white. Such black students may feel estranged and alienated in the class. Furthermore, their skepticism about the relevance of feminism may be regarded contemptuously by fellow students. Their relentless efforts to link all discussions of gender with race may be seen by white students as deflecting attention away from feminist concerns and thus contested. Suddenly, the feminist classroom is no longer a safe haven, the way many women's studies students imagine it will be, but is instead a site of conflict, tensions, and sometimes ongoing hostility. Confronting one another across differences means that we must change ideas about how we learn; rather than fearing conflict we have to find ways to use it as a catalyst for new thinking, for growth. Black students often bring this positive sense of challenge, of rigorous inquiry to feminist studies.

Teachers (many of whom are white) who find it difficult to address diverse responses may be as threatened by the perspec-

tives of black students as their classmates. Unfortunately, black students often leave such classes thinking they have acquired concrete confirmation that feminism does not address issues from a standpoint that includes race or addresses black experience in any meaningful way. Black women teachers committed to feminist politics may welcome the presence of a diverse student body in classrooms even as we recognize that it is difficult to teach Women's Studies to black students who approach the subject with grave doubt about its relevance. In recent years, I have been teaching larger numbers of black male students, many of whom are not aware of the ways sexism informs how they speak and interact in a group setting. They face challenges to behavior patterns they may have never before thought important to question. Towards the end of one semester, Mark, a black male student in my "Reading Fiction" English class, shared that while we focused on African American literature, his deepest sense of "awakening" came from learning about gender, about feminist standpoints.

When I teach courses such as "Black Women Writers" or "Third World Literature," I usually have more black students than those courses that are specifically designated as Women's Studies. I taught one Women's Studies senior seminar for a professor who was on leave. Too late, I realized that this course was really for Women's Studies majors and, as a consequence, would probably be all white. Described as a course that would approach feminist theory from a standpoint that included discussions of race, gender, class, and sexual practice, the first class attracted more black students than any other Women's Studies course I have taught. Talking individually with black students interested in the course, I found that the majority had little or no background in feminist studies. Only two students, one male and one female, were prepared to take the class. My suggestion to the other students was that they look at the assigned material to see if they were interested in it, if it was

accessible. They decided for themselves that they were not pre-
pared for the seminar and eagerly proposed another option,
which was that I would allow them to explore feminist theory—
particularly work by black women—in a private reading course
with ten black female students.

When we first met, the students expressed the sense that
they were transgressing boundaries by choosing to explore
feminist issues. Very much a militant advocate of feminist poli-
tics before taking the course, Lori (one of the few students who
had a Women's Studies background) told the group that it was
difficult to share with other black students, particularly male
peers, her interest in feminism: "I see how it is when I talk to
one individual black man who does not want to have anything
to do with feminism and then lets me know that nobody wants
to hear it." Challenging them to explore what makes the risk
worth taking, I heard varied responses. Several students talked
about witnessing male abuse of women in families and commu-
nities and seeing the struggle to end sexism as the only orga-
nized way to make changes. Maelinda, who is Afrocentric in
her thinking and plans to spend a year in Zimbabwe, told the
group that she considers it misguided for black women to act as
though we have the luxury to take feminism or leave it, espe-
cially if it is rejected because peers respond negatively: "I don't
think we really have that choice, that's like saying I don't want
to have race consciousness because the rest of society doesn't
want you to. I mean, let's get real."

Throughout the semester, there was more laughter in our
discussions—as well as more concern about negative fall-out
exploring feminist concerns—than in any feminist course I
have taught. There were also ongoing attempts to relate mater-
ial to the concrete realities they face as young black women. All
the students were heterosexual and particularly concerned
about the possibility that choosing to support feminist politics
would alter their relationships with black men. They were con-

cerned about ways feminism might change how they relate to
fathers, lovers, friends. Most everyone agreed that the men
they knew who were grappling with feminist issues were either
gay or involved with women who were "pushing them." Brett, a
close partner of one of the women, was taking another class
with me. Since he was named by black women in the group as
one of the black males who was concerned about gender issues,
I talked with him specifically about feminism. He responded by
calling attention to the reasons it is difficult for black men to
deal with sexism, the primary one being that they are accus-
tomed to thinking of themselves in terms of racism, being
exploited and oppressed. Speaking of his efforts to develop
feminist awareness, he stressed limitations: "I've tried to under-
stand but then I'm a man. Sometimes I don't understand and it
hurts, 'cause I think I'm the epitome of everything that's
oppressed." Since it is difficult for many black men to give
voice to the ways they are hurt and wounded by racism, it is also
understandable that it is difficult for them to "own up to" sex-
ism, to be accountable. More and more, individual black men
—particularly young black men—are facing the challenge of
daring to critique gender, be informed, and willingly resist and
oppose sexism. On college campuses, black male students are
increasingly compelled by black female peers to think about
sexism. Recently, I gave a talk where Pat, a young black man,
was wearing a button that read "Sexism is a male disease: Let's
solve it ourselves." Pat was into rap and he gave me a tape of rap
that opposed rape.

During our last private reading session, I asked black women
students whether they felt empowered by the material, if they
had grown in their feminist consciousness, if they were more
aware. Several commented that the material suggested to them
that black women active in feminist movement "have more ene-
mies" than other groups, and were more frequently attacked. In
their own lives they felt it was difficult to speak out and share

feminist thinking. Lori posed the question, "What would happen to a black feminist woman if she spoke as militantly as a black man?" She answered it herself: "People would freak out and start rioting." We all laughed at this. I assured them that I speak militantly about feminism in a black context and though there is often protest, there is also growing affirmation.

Everyone in the group expressed the fear that a commitment to feminist politics would lead them to be isolated. Carolyn, the student who organized the private reading, selecting much of the work that was studied, felt she was already more alone, under attack: "We see the alienation that black feminists experience by speaking out and ask ourselves, 'Are you strong enough to handle the isolation, the criticism?' You know you're going to get it from men and even some women." Overall, the feeling of the group was that studying feminist work, seeing an analysis of gender from a feminist standpoint as a way to understand black experience, was necessary for the collective development of black consciousness, for the future of black liberation struggle. Rebecca, a Southerner, felt that her upbringing made it easier to accept notions of gender equality in the workplace but harder to apply it to personal relationships. Individually, everyone spoke emphatically about critically examining their standpoints and transforming their consciousness as a first stage in the process of feminist politicization. Carolyn added to this comment her conviction that "once you learn to look at yourself critically, you look at everything around you with new eyes."

a self-critical perspective

Audre Lorde's essay "Eye to Eye" was one of the very first readings on the list. It was the work everyone called to mind in our class as we spoke about how important it is for black women to stand in feminist solidarity with one another. Tensions had emerged in the group between students who felt that individuals would come to class and "talk feminism" but not act on their beliefs in other settings. There was silence when Tanya

reminded the group of the importance of honesty, of facing oneself. Everyone agreed with Carolyn that black women who "get it together," who deal with sexism and racism, develop important strategies for survival and resistance that need to be shared within black communities, especially since (as they put it) the black woman who gets past all this and discovers herself "holds the key to liberation."

9

Feminist Scholarship

Black Scholars

More than twenty years have passed since I wrote my first feminist book, *Ain't I a Woman: Black Women and Feminism*. Like many precocious girls growing up in a male-dominated household, I understood the significance of gender inequality at an early age. Our daily life was full of patriarchal drama—the use of coercion, violent punishment, verbal harassment, to maintain male domination. As small children we understood that our father was more important than our mother because he was a man. This knowledge was reinforced by the reality that any decision our mother made could be overruled by our dad's authority. Since we were raised during racial segregation, we lived in an all-black neighborhood, went to black schools, attended a black church. Black males held more power and authority than black females in all these institutions. It was only when I entered college that I learned that black males had supposedly been "emasculated," that the trauma of slavery was pri-

marily that it had stripped black men of their right to male priv-
ilege and power, that it had prevented them from fully actualiz-
ing "masculinity." Narratives of castrated black men, humble
Stepin Fetchits who followed white men as though they were lit-
tle pets, was to my mind the stuff of white fantasy, of racist imag-
ination. In the real world of my growing up I had seen black
males in positions of patriarchal authority, exercising forms of
male power, supporting institutionalized sexism.

Given this experiential reality, when I attended a predomi-
nantly white university, I was shocked to read scholarly work on
black life from various disciplines like sociology and psychology
written from a critical standpoint which assumed no gender
distinctions characterized black social relations. Engaged in my
undergraduate years with emergent feminist movement, I took
Women's Studies classes the moment they were offered. Yet, I
was again surprised by the overwhelming ignorance about
black experience. I was disturbed that the white female profes-
sors and students were ignorant of gender differences in black
life—that they talked about the status and experiences of
"women" when they were only referring to white women. That
surprise changed to anger. I found my efforts ignored when I
attempted to share information and knowledge about how, de-
spite racism, black gender relations were constructed to main-
tain black male authority even if they did not mirror white
paradigms, or about the way white female identity and status
was different from that of black women.

In search of scholarly material to document the evidence of
my lived experience, I was stunned by either the complete lack
of any focus on gender difference in black life or the tacit
assumption that because many black females worked outside
the home, gender roles were inverted. Scholars usually talked
about black experience when they were really speaking solely
about black male experience. Significantly, I found that when
"women" were talked about, the experience of white women

was universalized to stand for all female experience and that when "black people" were talked about, the experience of black men was the point of reference. Frustrated, I begin to interrogate the ways in which racist and sexist biases shaped and informed all scholarship dealing with black experience, with female experience. It was clear that these biases had created a circumstance where there was little or no information about the distinct experiences of black women. It was this critical gap that motivated me to research and write *Ain't I a Woman*. It was published years later, after publishers of feminist work accepted that "race" was both an appropriate and marketable subject within the field of feminist scholarship. This acceptance came only when white women began to show an interest in issues of race and gender.

When contemporary feminist movement first began, feminist writings and scholarship by black women was groundbreaking. The writings of black women like Cellestine Ware, Toni Cade Bambara, Michele Wallace, Barbara Smith, and Angela Davis, to name a few, were all works that sought to articulate, define, speak to and against the glaring omissions in feminist work, the erasure of black female presence. During these early years, white women were zealously encouraging the growth and development of feminist scholarship that specifically addressed their reality, the recovery of buried white women's history, documentary evidence that would demonstrate the myriad ways gender differences were socially constructed, the institutionalization of inequality. Yet there was no concurrent collective zeal to create a body of feminist scholarship that would address the specific realities of black women. Again and again black female activists, scholars, and writers found ourselves isolated within feminist movement and often the targets of misguided white women who were threatened by all attempts to deconstruct the category "woman" or to bring a discourse on race into feminist scholarship. In those days, I imagined that my work and that of

other black women would serve as a catalyst generating greater engagement by black people, and certainly black females, in the production of feminist scholarship. But that was not the case. For the most part, black folks, along with many white women, were suspicious of black women who were committed to feminist politics.

Black discourse on feminism was often confined to endless debates about whether or not black women should involve ourselves in "white feminist" movement. Were we black or women first? The few black women academics who were seeking to make critical interventions in the development of feminist theory were compelled to first "prove" to white feminists that we were on target when we called attention to racist biases that distorted feminist scholarship, that failed to consider the realities of women who were not white or from privileged classes. Though this strategy was necessary for us to gain a hearing, an audience, it meant that we were not concentrating our energies on creating a climate where we could focus intensively on creating a body of scholarship that would look at black experience from a feminist standpoint. By focusing so much attention on racism within feminist movement, or proving to black audiences that a system of gender inequality permeated black life, we did not always direct our energies towards inviting other black folks to see feminist thinking as a standpoint that could illuminate and enhance our intellectual understanding of black experience. It seemed that individual black women active in feminist politics were often caught between a rock and a hard place. The vast majority of white feminists did not welcome our questioning of feminist paradigms that they were seeking to institutionalize; so too, many black people simply saw our involvement with feminist politics as a gesture of betrayal, and dismissed our work.

Despite the racism we confronted within feminist circles, black women who embraced feminist thinking and practice

remained committed and engaged because we experienced new forms of self-improvement. We understood and understand now how much a critique of sexism and organized efforts to affirm feminist politics in black communities could be liberatory for women *and* men. Black women thinkers and writers like Michele Wallace and Ntozake Shange, who initially had huge black audiences responding to the emphasis in their work on sexism, on gender differences in black life, faced hostile black audiences who were not willing to dialogue. Many black female writers witnessing the black public's response to their work were fearful that engagement with feminist thinking would forever alienate them from black communities. Responding to the idea that black women should become involved with feminist movement, many black people insisted that we were already "free," that the sign of our freedom was that we worked outside the home. Of course, this line of thinking completely ignores issues of sexism and male domination. Since the ruling rhetoric at the time insisted on the complete "victimization" of black men within white supremacist patriarchy, few black folks were willing to engage that dimension of feminist thought that insisted that sexism and institutionalized patriarchy indeed provide black men with forms of power, however relative, that remained intact despite racist oppression. In such a cultural climate, black women interested in creating feminist theory and scholarship wisely focused their attention on those progressive folks, white women among them, who were open to interrogating critically issues of gender in black life from a feminist standpoint.

Significantly, as feminist movement progressed, black women and women of color who dared to challenge the universalization of the category "woman" created a revolution in feminist scholarship. Many white women who had previously resisted rethinking the ways feminist scholars talked about the status of women now responded to critiques and worked to create a criti-

cal climate where we could talk about gender in a more complex way, and where we could acknowledge differences in female status that were overdetermined by race and class. Ironically, this major intervention did not serve as a catalyst compelling more black women to do feminist work. Currently, many more white women than black women do scholarship from a feminist standpoint that includes race. This is so because many academic black women remain ambivalent about feminist politics and the feminist standpoints. In her essay, "Toward a Phenomenology of Feminist Consciousness," Sandra Bartky makes the point that "to be a feminist, one has first to become one." She reminds us that just thinking about gender or lamenting the female condition "need not be an expression of feminist consciousness." Indeed, many black women academics chose to focus attention on gender even as they very deliberately disavowed engagement with feminist thinking. Uncertain about whether feminist movement would really change the lives of black females in a meaningful way, they were not willing to assume and assert a feminist standpoint.

Another factor that restricted black female participation in the production of feminist scholarship was and is the lack of institutional rewards. While many academic white women active in feminist movement became a part of a network of folks who shared resources, publications, jobs and so on, black females were often out of this loop. This was especially the case for individual black women creating feminist scholarship that was not well received. In the early stages of my work, white women scholars were often threatened by its focus on race and racism. Far from being rewarded or valued (as is the case now), in those days I was perceived as a threat to feminism. It was even more threatening when I dared to speak from a feminist standpoint on issues other than race. Overall, black female scholars, already seriously marginalized by the institutionalized

racism and sexism of the academy, have never been fully con-
vinced that it is advantageous for them to declare publicly a
commitment to feminist politics, either for reasons of career
mobility or personal well-being. Many of us have relied on net-
works with black male scholars to help further our careers.
Some of us have felt and still feel that claiming a feminist stand-
point will alienate these allies.

[handwritten margin note: because of the relatively small number of black scholars, all of whom are marginalized?]

Despite many factors that have discouraged black women
from producing feminist scholarship, the system of rewards for
such work has recently expanded. Work in feminist theory is
seen as academically legitimate. More black women scholars
than ever before are doing work that looks at gender. Grad-
ually, more of us are doing feminist scholarship. Literary criti-
cism has been the location that has most allowed black female
academics to claim a feminist voice. Much feminist literary crit-
icism responded to the work of black women fiction writers
which exposed forms of gender exploitation and oppression in
black life; this literature was receiving unprecedented atten-
tion, and speaking critically about it was not a risky act. These
works spoke to feminist concerns. Black women writing about
such concerns could address them, often without having to
claim a feminist standpoint. More than any nonfiction feminist
writing by black women, fiction by writers like Alice Walker and
Ntozake Shange served as a catalyst, stimulating fierce critical
debate in diverse black communities about gender, about fem-
inism. At that time, nonfiction feminist writing was most often
ignored by black audiences. (Michele Wallace's *Black Macho
and the Myth of the Superwoman* was a unique exception.) White
women academics were usually accepting of black females
doing literary criticism that focused on gender or made refer-
ence to feminism, but they still saw the realm of feminist theo-
ry as their critical domain. Not surprisingly, work by black
literary critics received attention and at times acclaim. Black

women scholars like Hazel Carby, Hortense Spillers, Beverly Guy-Sheftall, Valerie Smith, and Mae Henderson used a feminist standpoint in the production of literary scholarship.

Despite a burgeoning body of literary criticism by black women from a feminist standpoint, more often than not black women academics focused attention on issues of gender without specifically placing their work within a feminist context. Historians like Rosalyn Terborg Penn, Deborah White, and Paula Giddings chose critical projects that were aimed at restoring buried knowledge of black female experience. Their work —and that of many other black female historians—has expanded and continues to expand our understanding of the gendered nature of black experience, even though it does not overtly insist on a relationship to feminist thinking. A similar pattern developed in other disciplines. What this means is that we have an incredible work built around the issue of gender-enhancing feminist scholarship without explicitly naming itself as feminist.

Clearly, contemporary feminist movement created the necessary cultural framework for an academic legitimation of gender-based scholarship: the hope was that this work would always emerge from a feminist standpoint. Conversely, work on gender that does not emerge from such a standpoint situates itself in an ambivalent, even problematic, relationship to feminism. A good example of such a work is Deborah White's *Ar'n't I a Woman*. Published after *Ain't I a Woman,* this work, whether intentionally or not, mirrored my work's concern with re-thinking the position of black women in slavery. (White makes no reference to my work—a fact which is only important because it coincides with the absence of any mention of feminist politics.) Indeed, one can read White's work as a corrective to interdisciplinary nontraditional academic work that frames the study of women within a feminist context. She presents her work as politically neutral scholarship. Yet, the absence of feminist

standpoint or references pointedly acts to de-legitimize and invalidate such work even as it appropriates the issues and the audience feminist movement and feminist scholarship creates. Given that so little solid academic factual work is done to document our history, White's work is a crucial contribution even though it exposes the ambiguous relationship many black women scholars have to feminist thought.

When that ambiguity converged with the blatant antifeminism characteristic of many black male thinkers, there was no positive climate for black scholars collectively to embrace and support sustained production of feminist work. Even though individual black scholars still choose to do this work, and more recent graduate students dare to place their work in a feminist context, the lack of collective support has resulted in a failure to create the very education for critical consciousness that would teach unknowing black folks why it is important to examine black life from a feminist standpoint. The current antifeminist backlash in the culture as a whole undermines support for feminist scholarship. Since black feminist scholarship has always been marginalized in the academy, marginal to the existing academic hegemony as well as to the feminist mainstream, those of us who believe such work is crucial to any unbiased discussion of black experience must intensify our efforts to educate for critical consciousness. Those black women scholars who began working on gender issues while still ambivalent about feminist politics and who have now grown in both their awareness and commitment must be willing to discuss publicly the shifts in their thinking.

This page intentionally left blank

10

Building a Teaching Community

A Dialogue

In their introduction to the essay collection *Between Borders: Pedagogy and the Politics of Cultural Studies,* editors Henry Giroux and Peter McLaren emphasize that those critical thinkers working with issues of pedagogy who are committed to cultural studies must combine "theory and practice in order to affirm and demonstrate pedagogical practices engaged in creating a new language, rupturing disciplinary boundaries, decentering authority, and rewriting the institutional and discursive borderlands in which politics becomes a condition for reasserting the relationship between agency, power, and struggle." Given this agenda, it is crucial that critical thinkers who want to change our teaching practices talk to one another, collaborate in a discussion that crosses boundaries and creates a space for intervention. It is fashionable these days, when "difference" is a hot topic in progressive circles, to talk about "hybridity" and "border crossing," but we often have no concrete

examples of individuals who actually occupy different locations within structures, sharing ideas with one another, mapping out terrains of commonality, connection, and shared concern with teaching practices.

To engage in dialogue is one of the simplest ways we can begin as teachers, scholars, and critical thinkers to cross boundaries, the barriers that may or may not be erected by race, gender, class, professional standing, and a host of other differences. My first collaborative dialogue was with philosopher Cornel West, published in *Breaking Bread: Insurgent Black Intellectual Life*. Then I participated in a really exciting critical exchange with feminist literary critic Mary Childers, published in *Conflicts in Feminism*. The first dialogue was meant to serve as a model for critical exchange between male and female, and among black scholars. The second was meant to show that solidarity can and does exist between individual progressive white and black feminist thinkers. In both cases there seemed to be much more public representation of the divisions between these groups than description or highlighting of those powerful moments when boundaries are crossed, differences confronted, discussion happens, and solidarity emerges. We needed concrete counter-examples that would disrupt the seemingly fixed (yet often unstated) assumptions that it was really unlikely such individuals could meet across boundaries. Without these counter-examples I felt we were all in danger of losing contact, of creating conditions that would make contact impossible. Hence, I formed my conviction that public dialogues could serve as useful interventions.

When I began this collection of essays, I was particularly interested in challenging the assumption that there could be no points of connection and camaraderie between white male scholars (often seen, rightly or wrongly, as representing the embodiment of power and privilege or oppressive hierarchy) and marginalized groups (women of all races or ethnicities,

and men of color). In recent years, many white male scholars have become critically engaged with my writing. It troubles me that this engagement has been viewed suspiciously or seen merely as an act of appropriation meant to enhance opportunistic agendas. If we really want to create a cultural climate where biases can be challenged and changed, all border crossings must be seen as valid and legitimate. This does not mean that they are not subjected to critique or critical interrogation, or that there will not be many occasions when the crossings of the powerful into the terrains of the powerless will not perpetuate existing structures. This risk is ultimately less threatening than a continued attachment to and support of existing systems of domination, particularly as they affect teaching, how we teach, and what we teach.

To provide a model of possibility, I chose to engage in a dialogue with Ron Scapp, a white male philosopher, comrade, and friend. Until recently he taught in the philosophy department at Queens College, and worked as the Director of the College Preparatory Program in the School of Education, and the author of a manuscript entitled *A Question of Voice: The Search for Legitimacy.* Currently, he is Director of the Graduate Program in Urban Multi-Cultural Education at the College of Mount St. Vincent. I first met Ron when I came to Queens College in the company of twelve students who were taking the Toni Morrison seminar I taught at Oberlin College. We went to a conference on Morrison where she spoke, and where I gave a talk as well. My critical perspective on her work, especially *Beloved,* was not well received. As I was leaving the conference, surrounded by students, Ron approached me and shared his responses to my ideas. This was the beginning of an intense critical exchange about teaching, writing, ideas, and life. I wanted to include this dialogue because we inhabit different locations. Even though Ron is white and male (two locations that bestow specific powers and privileges), I have taught primarily at private institu-

tions (deemed more prestigious than the state institutions where we both now teach) and have higher rank, and more prestige. We both come from working-class backgrounds. His roots are in the city, mine in rural America. Understanding and appreciating our different locations has been a necessary framework for the building of professional and political solidarity between us, as well as for creating a space of emotional trust where intimacy and regard for one another can be nourished.

Over the years, Ron and I have had many discussions about our role as critical thinkers, professors in the academy. Just as I have had to confront critics who see my work as "not scholarly, or not scholarly enough," Ron has had to deal with critics posing the question of whether he is doing "real philosophy," especially when he draws on my work and that of other thinkers who have not had traditional training in philosophy. Both of us are passionately committed to teaching. Our shared concern that the role of the teacher not be devalued was a starting point for this discussion. It is our hope that it will lead to many such discussions, that it will show that white males can and do change how they think and teach, and that interaction across and with our differences can be meaningful and enrich our teaching practices, scholarly work, and habits of being within and outside the academy.

bell hooks: Ron, let's start with talking about how we see ourselves as teachers. One of the ways that this book has made me think about my teaching process is that I feel that the way I teach has been fundamentally structured by the fact that I never wanted to be an academic, so that I never had a fantasy of myself as a professor already worked out in my imagination before I entered the classroom. I think that's been meaningful, because it's freed me up to feel that the professor is something I become as

opposed to a kind of identity that's already structured and that I carry with me into the classroom.

Ron Scapp: And in a similar but perhaps slightly different mode, it's not so much that I never wanted to be a professor—I never thought about it. All my life was very much outside the classroom. Many of my friends never went on to finish college—some of them didn't finish high school —so there was not the thing about school as a professional track, and I think your not wanting to be a professor was not wanting that professional identification as such. I never even thought about it.

bh: But like you said, I didn't either. I mean, as a young, black woman in the segregated South, I thought—and my parents thought—that I would return to that world and be a teacher in the public school. But there was never any idea that I could be a university professor because, truth be told, we didn't know of any black women university professors.

RS: In a different but similar way, my parents, working class, saw education as really a means to an end, not the end point, so that as one got a university education, one went on to be a lawyer or a doctor. For them it was a means to enhance your economic status. Not that they look down at university professors, it just wasn't what one *did*. One got educated to earn money, a living, and start a family.

bh: How long have you been teaching?

RS: I started at LaGuardia Community College when I graduated Queens College in 1979. I was in the remedial basic skills department. We taught remedial reading and English.

bh: And then you went on to get your Ph.D. in philosophy?

RS: Yes, so I was teaching during graduate school. Since 1979 I've been involved teaching part-time or full-time. So, what's that, fourteen years?

bh: I've been teaching since I was 21. As a graduate student I taught my own courses using African American Literature and African American women's stuff just because I was interested in doing that and there was a student body willing to take those courses. But I was a late bloomer in terms of getting my Ph.D., even though I was already in the classroom. I see myself having been in the college classroom for 20 years. It's interesting that you and I would meet when I brought my Oberlin students to Queens for a conference. I think that part of what we connected to was a concern, evidenced by the paper I gave, with not just the academic work we were doing in the classroom, but how that academic work affects us beyond the classroom. We've spent the years since our meeting talking about pedagogy and teaching; one of the things that has connected us is that we both have a real concern with education as liberatory practice and with pedagogical strategies that may be not just for our students but for ourselves.

RS: Absolutely. That's also a nice way of understanding or describing how I, in fact, came to feel more and more comfortable about the role of professor.

bh: I want to return to the idea that somehow it was my disinvestment in the notion of the professor or academic as my identity that I think has made me more willing to question and interrogate this role. If perhaps we look at where I really do see my identity, which is more often as a writer, maybe I'm much less flexible in imagining that practice than I am in seeing myself as a professor. I feel I've benefited a lot from not being attached to myself as an academic or professor. It's made me willing to be critical of my own pedagogy and to accept criticism from my students and other people without feeling that to question how I teach is somehow to question my right to exist on the planet. I feel that one of the things blocking a lot

of professors from interrogating their own pedagogical practices is that fear that *"this is my identity and I can't question that identity."*

RS: We were talking about professional direction—that's maybe an awkward expression—an attempt to get at a sense of calling. We talked about the difference between seeing the title of professor or university teacher or even just teacher itself as a mere professional bridge like lawyer or doctor, a term that within our own working-class communities brought prestige or significance to who we already were. But as teachers I think our emphasis has, over the years, been to affirm who we are through the transaction of being with other people in the classroom and achieving something there. Not just relaying information or stating things, but working with people.

We were talking a little bit earlier about the way in which we are physically in that space, coming into it from the community.

bh: One of the things I was saying is that, as a black woman, I have always been acutely aware of the presence of my body in those settings that, in fact, invite us to invest so deeply in a mind/body split so that, in a sense, you're almost always at odds with the existing structure, whether you are a black woman student or professor. But if you want to remain, you've got, in a sense, to remember yourself—because to remember yourself is to see yourself always as a body in a system that has not become accustomed to your presence or to your physicality.

RS: Similarly, as a white university teacher in his thirties, I'm profoundly aware of my presence in the classroom as well, given the history of the male body, and of the male teacher. I need to be sensitive to and critical of my presence in the history that has led me there. Yet it's complicated by the fact that you and I are both sensitive to—and

maybe even suspicious of—those who seem to be retreating away from a real, maybe radical consciousness of the body into a very conservative mind/body split. Some male colleagues are hiding behind this, repressing their bodies not out of deference but out of fear.

bh: And it's interesting that it is in those private spaces where sexual harassment goes on—in offices or other kinds of spaces—one has to experience the revenge of the repressed. We talked about Michel Foucault as an example of someone who in theory seemed to challenge those simplistic binary oppositions and mind/body splits. But in his life practice as a teacher, he clearly made a separation between that space where he saw himself as a practicing intellectual—where he not only saw himself as a critical thinker but was seen as a critical thinker—and that space where he was *body*. It really is clear that the space of high culture was where he was in mind, and the space of the street and street culture (and popular culture, marginalized culture) was where he felt he could be most expressive of himself within the body.

RS: He's quoted as saying that he felt most free in the baths in San Francisco. In his writing maybe there isn't so much of that division and dualism, but as far as I know—never having been in a classroom with him—he took the pose of the traditional French intellectual very seriously.

bh: As a traditional *white* male French intellectual. It's important that you add that because we can't even name any black male French intellectuals off the bat. Even though we know that they must exist; like the rest of Europe, France is no longer white.

I think that one of the unspoken discomforts surrounding the way a discourse of race and gender, class and sexual practice has disrupted the academy is precisely the challenge to that mind/body split. Once we start

talking in the classroom about the body and about how
we live in our bodies, we're automatically challenging the
way power has orchestrated itself in that particular institu-
tionalized space. The person who is most powerful has
the privilege of denying their body. I remember as an
undergraduate I had white male professors who wore the
same tweed jacket and rumpled shirt or something, but
we all knew that we had to pretend. You would never com-
ment on his dress, because to do so would be a sign of
your own intellectual lack. The point was we should all
respect that he's there to be a mind and not a body.

Certain feminist thinkers—and the two people who
come to my mind in this way are, interestingly, Lacan
scholars, Jane Gallop and Shoshana Felman—have tried
to write about the presence of the teacher as a body in the
classroom, the presence of the teacher as someone who
has a total effect on the development of the student, not
just an intellectual effect but an effect on how that stu-
dent perceives reality beyond the classroom.

RS: These are all things that weigh heavily on anyone who's
taking seriously the history of the body of knowledge that
is personified in the teacher. We were talking about how,
in a way, our work brings our selves, our bodies into the
classroom. The traditional notion of being in the class-
room is a teacher behind a desk or standing at the front,
immobilized. In a weird way that recalls the firm, immo-
bilized body of knowledge as part of the immutability of
truth itself. So what if one's clothing is soiled, if one's
pants are not adjusted properly, or your shirt's sloppy. As
long as the mind is still working elegantly and eloquently,
that's what is supposed to be appreciated.

bh: Our romantic notion of the professor is so tied to a sense
of the transitive mind, a mind that, in a sense, is always at
odds with the body. I think part of why everyone in the

that's why they'd get freaked when they see us in public spaces the outside the classroom university —

culture, and students in general, have a tendency to see professors as people who don't work is totally tied to that sense of the immobile body. Part of the class separation between what we do and what the majority of people in this culture can do (service, work, labor) is that they move their bodies. Liberatory pedagogy really demands that one work in the classroom, and that one work with the limits of the body, work both with and through and against those limits: teachers may insist that it doesn't matter whether you stand behind the podium or the desk, but it does. I remember in my early teaching days that when I first tried to move out beyond the desk, I felt really nervous. I remember thinking, "This really is about power. I really do feel more 'in control' when I'm behind the podium or behind the desk than when I'm walking towards my students, standing close to them, maybe even touching them." Acknowledging that we are bodies in the classroom has been important for me, especially in my efforts to disrupt the notion of professor as omnipotent, all-knowing mind.

Virtual teaching increases this immobility and "disembodiedness"

RS: When you leave the podium and walk around, suddenly the way you smell, the way you move become very apparent to your students. Also, you bring with you a certain kind of potential, though not guaranteed, for a certain kind of face-to-face relationship and respect for "what I say" and "what you say." Student and professor are looking at each other. And as we come physically close, suddenly what I have to say is not coming from behind this invisible line, this wall of demarcation that implies anything that from this side of the desk is gold, is truth, or that everything said out there is merely for my consideration, that the only possible way I can respond is by saying "good," "right," and so on. As people move around it becomes more evident that we *work* in the classroom. For some

teachers, and especially older faculty, there is a desire to enjoy the privilege of appearing not to work in the classroom. It's odd in and of itself, but it's particularly ironic since faculty members congregate outside the classroom and talk endlessly about how hard they're working.

bh: The arrangement of the body we are talking about de-emphasizes the reality that professors are in the classroom to offer something of our selves to the students. The erasure of the body encourages us to think that we are listening to neutral, objective facts, facts that are not particular to who is sharing the information. We are invited to teach information as though it does not emerge from bodies. Significantly, those of us who are trying to critique biases in the classroom have been compelled to return to the body to speak about ourselves as subjects in history. We are all subjects in history. We must return ourselves to a state of embodiment in order to deconstruct the way power has been traditionally orchestrated in the classroom, denying subjectivity to some groups and according it to others. By recognizing subjectivity and the limits of identity, we disrupt that objectification that is so necessary in a culture of domination. That is why the efforts to acknowledge our subjectivity and that of our students has generated both a fierce critique and backlash. Even though Dinesh D'Souza and Allan Bloom present this critique as fundamentally a critique of ideas, it is also a critique of how those ideas get subverted, disrupted, taken apart in the classroom.

RS: If professors take seriously, respectfully, the student body, we are compelled to acknowledge that we are addressing folks who are part of history. And some of them are coming from histories that might be threatening to the established ways of knowing if acknowledged. This is especially the case for professors and teachers who, in the class-

room, come face to face with individuals they do not see in their own neighborhoods. For example, in the urban university settings, on my own campus, a good number of the professors don't live in New York City; some don't live in New York state. They live in Connecticut or New Jersey or they live on Long Island. Many of their communities are very isolated, not reflecting the racial mixture of people that are on their campus. I think that this is why so many of these professors see themselves as liberal, even as they maintain conservative positions in the classroom. This seems especially so with issues of race. Many of us want to act as though race doesn't matter, that we are here for what's interesting in the mind, that history doesn't matter even if you've been screwed over, or your parents were immigrants or the children of immigrants who have labored for forty years and have nothing to show for it. Recognition of that must be suspended; and the rationale for this erasure is that logic which says, "What we do here is science, what we do here is objective history."

bh: It is fascinating to see the ways erasure of the body connects to the erasure of class differences, and more importantly, the erasure of the role of university settings as sites for the reproduction of a privileged class of values, of elitism. All these issues are exposed when Western civilization and canon formation are challenged and rigorously interrogated. That's exactly what's threatening to conservative academics—the possibility that such critiques will dismantle the bourgeois idea of a "professor" and that, as a consequence, the sense of our significance and our role as teachers in the classroom would need to be fundamentally changed. While writing the essays in this book, I continuously thought about the fact that I know so many professors who are progressive in their politics, who have been willing to change their curriculum, but who in fact

have resolutely refused to change the nature of their ped-
agogical practice.

RS: Many of these professors have no awareness of how they
conduct themselves in the classroom. For example, a
teacher might introduce works by you, or by intellectuals
from other groups underrepresented in the academy, yet
they will work with these texts, work with the ideas they
share, in ways that suggest there is ultimately no differ-
ence between this work and more conservative work
emerging from folks privileged by class, race, or gender.

bh: It's also really important to acknowledge that professors
may attempt to deconstruct traditional biases while shar-
ing that information through body posture, tone, word
choice, and so on that perpetuate those very hierarchies
and biases they are critiquing.

RS: Exactly. That's the problem. On the one hand, you have
the repetition of that whole tradition; and on the other
hand, what does it do to the text being presented? It
seems safer to present very radical texts as just so many
other books to be added to the traditional lists—the
already-existing canon.

bh: The example that comes to my mind is that of a white
female English professor who is more than happy to in-
clude Toni Morrison on her syllabus but who does not
want to discuss race when talking about the book. For she
sees this as a much more threatening interrogation of
what it means to be a professor than the call to change
the curriculum. And she is right to see the call to change
pedagogical strategies as risky. Certainly teachers who are
trying to institutionalize progressive pedagogical prac-
tices risk being subjected to discrediting critiques.

RS: That's right. Professors who in fact do evoke the necessity
of *tradition* could talk about it differently. Tradition
should be such a wonderful word, a rich word. Yet it is

often used in a negative sense to repeat the tradition of
the power of status quo. We could celebrate the tradition
of teachers who have created a curriculum that is pro-
gressive. But such a tradition is never named or valued;
even when reading radical texts there is a need to do so in
a way that validates the scholarship that they've been
raised on. They can't let go of it. Even when they read cer-
tain things in class, it has to be ultimately presented in a
fashion that is not inconsistent with everything else that
has come before it. But it devalues the significance, the
impact, of a work by Toni Morrison, or by yourself, if it is
not taught in a manner that goes against the grain. In
philosophy classes today, work on race, ethnicity, and
gender is used, but not in a subversive way. It is simply
used to update the curriculum superficially. This clinging
to the past is mandated by the profound belief in the
legitimacy of all that has come before. Teachers who have
these beliefs really have trouble experimenting and risk-
ing their bodies—the social order. They want the class-
room to be the way it has always been.

bh: I want to reiterate that many teachers who do not have
difficulty releasing old ideas, embracing new ways of
thinking, may still be as resolutely attached to old ways of
practicing teaching as their more conservative colleagues.
That's a crucial issue. Even those of us who are experi-
menting with progressive pedagogical practices are afraid
to change. Aware of myself as a subject in history, a mem-
ber of a marginalized and oppressed group, victimized by
institutionalized racism, sexism, and class elitism, I had
tremendous fear that I would teach in a manner that
would reinforce those hierarchies. Yet I had absolutely no
model, no example of what it would mean to enter a class-
room and teach in a different way. The urge to experi-
ment with pedagogical practices may not be welcomed by

students also reinforce traditional hierarchies — (handwritten margin note)

students who often expect us to teach in the manner they are accustomed to. My point is that it takes a fierce commitment, a will to struggle, to let our work as teachers reflect progressive pedagogies. There is a critique of progressive pedagogical practices that comes at us not just from the inside but from the outside as well. Bloom and D'Souza reached a mass audience and were able to give a distorted impression of progressive pedagogy. It's frightening to me that the mass media has not only offered the public a sense that there really has been some kind of revolution in education where conservative white men are just completely discredited when we know that very little has changed, that only a tiny group of professors advocate progressive pedagogy. We inhabit real institutions where very little seems to be changed, where there are very few changes in the curriculum, almost no paradigm shifts, and where knowledge and information continue to be presented in the conventionally accepted manner.

RS: As you were saying earlier, conservative thinkers have managed to make their argument outside the university and even persuade students that the quality of their education will diminish if changes are made. For example, I think many students confuse a lack of recognizable traditional formality with a lack of seriousness.

bh: What's really scary is that the negative critique of progressive pedagogy affects us—makes teachers afraid to change—to try new strategies. Many feminist professors, for example, begin their careers working to institutionalize more radical pedagogical practices, but when students did not appear to "respect their authority" they felt these practices were faulty, unreliable, and returned to traditional practices. Of course, they should have expected that students who have had a more conventional education would be threatened by and even resist teaching

[Handwritten margin note: how do we change this?? If they don't read—they can't read or discuss critically]

practices which insist that students participate in education and not be passive consumers.

RS: That's very difficult to communicate to students because many of them are already convinced that they cannot respond to appeals that they be engaged in the classroom, because they've already been trained to view themselves as not the ones in authority, not the ones with legitimacy. To acknowledge student responsibility for the learning process is to place it where it's least legitimate in their own eyes. When we try to change the classroom so that there is a sense of mutual responsibility for learning, students get scared that you are now not the captain working with them, but that you are after all just another crew member—and not a reliable one at that.

bh: To educate for freedom, then, we have to challenge and change the way everyone thinks about pedagogical process. This is especially true for students. Before we try to engage them in a dialectical discussion of ideas that is mutual, we have to teach about process. I teach many white students and they hold diverse political stances. Yet they come into a class on African American women's literature expecting to hear no discussion of the politics of race, class, and gender. Often these students will complain, "Well I thought this was a literature class." What they're really saying to me is, "I thought this class was going to be taught like any other literature class I would take, only we would now substitute black female writers for white male writers." They accept the shift in the locus of representation but resist shifting ways they think about ideas. That is threatening. That's why the critique of multiculturalism seeks to shut the classroom down again—to halt this revolution in how we know what we know. It's as though many people know that the focus on difference has the potential to revolutionize the classroom and they

do not want the revolution to take place. There is a major backlash that seeks to delegitimize progressive pedagogy by saying, "This keeps us from having serious thoughts and serious education." That critique returns us to the issue surrounding teaching differently. How do we cope with how we are perceived by our colleagues? I've actually had colleagues say to me, "Students seem to really enjoy your class. What are you doing wrong?"

RS: Colleagues say to me, "Your students seem to be enjoying themselves, they seem to be laughing whenever I walk by, you seem to be having a good time." And the implication is that you're a good joke-teller, you're a good performer, but no serious teaching is happening. Pleasure in the classroom is feared. If there is laughter, a reciprocal exchange may be taking place. You're laughing, the students are laughing, and someone walks by, looks in and says, "OK, you're able to make them laugh. But so what? Anyone can entertain." They can take this attitude because the idea of reciprocity, of respect, is not ever assumed. It is not assumed that your ideas can be entertaining, moving. To prove your academic seriousness, students should be almost dead, quiet, asleep, not up, excited, and buzzing, lingering around the classroom.

bh: It is as though we are to imagine that knowledge is this rich creamy pudding students should consume and be nourished by, but not that the process of gestation should also be pleasurable. As a teacher working to develop liberatory pedagogy I am discouraged when I encounter students who believe if there's a different practice they can be less committed, less disciplined. I think our fear of losing students' respect has discouraged many professors from trying new teaching practices. Instead, some of us think, "I must return to the traditional way of doing it, otherwise I don't get the respect, and the students don't

get the education they deserve because they don't listen."
When I was a student, I embraced any professor who want-
ed to create more progressive teaching practices. I still
remember the excitement I felt when I took my first class
where the teacher wanted to change how we sat, where we
moved from sitting in rows to a circle where we could look
at one another. That change forced us to recognize one
another's presence. We couldn't sleepwalk our way to
knowledge. Nowadays, there are times when students
resist sitting in a circle. They devalue that shift, because
fundamentally, they don't want to be participants.

it's more work to be active to be than to be passive

RS: They see this practice as an empty gesture, not as an
important pedagogical shift.

bh: They may think, "Why should I have to do this in your
class, but not in all my other classes?" It's been amazing
and discouraging to encounter the resisting student, who
is not open to liberatory practice, even as I simultaneous-
ly see so many students craving liberatory practice.

RS: Even students who long for liberatory education, who
appreciate it, find themselves resisting because they have
to go to other classes where the class begins at a certain
time, ends at a certain time, where all these regulations
are in place as modes of expression of power, rather than
what needs to be done to have some sense of possibility
for sustained conversation. As we said earlier, we can
intervene and change resistance by sharing our under-
standing of practice. I tell students not to confuse infor-
mality with a lack of seriousness, to respect the process.
Because I teach in an informal way, students often feel
like they can just get up, walk out, and come back. They
are not comfortable. And I remind them that in their
other classes where the teacher says if you miss one class
you're out of the class, they are docile, willing to comply
with arbitrary rules about behavior.

bh: I had an interesting experience last semester teaching at City College. I couldn't come to class one day and I had a substitute come, a person who was much more a traditional thinker, a traditional authoritarian, and the students conformed for the most part to those pedagogical practices. When I returned and I asked, "Well, what happened in class?" the students shared their perception that she had really humiliated a student, used her power forcibly to silence. "Well, what did you all say?" I asked. They admitted that they had sat there silently. These revelations made me see how deeply ingrained is the student perception that professors can be and should be dictators. To some extent, they saw me as "dictating" that they engage in liberatory practice, so they complied. Hence when another teacher entered the classroom and was more authoritarian they simply fell into line. But the triumph of liberatory pedagogy was that we had the space to interrogate their actions. They could look at themselves and say, "Why didn't we stand up for what we believe? Why didn't we maintain the value of our class? Do we see ourselves simply acting in complicity with her vision of liberatory practice, or are we committed to this practice ourselves?"

RS: Weren't their responses probably influenced by habit?

bh: It's very important to emphasize habit. It's so difficult to change existing structures because the habit of repression is the norm. Education as the practice of freedom is not just about liberatory knowledge, it's about a liberatory practice in the classroom. So many of us have critiqued the individual white male scholars who push critical pedagogy yet who do not alter their classroom practices, who assert race, class, and gender privilege without interrogating their conduct.

RS: In the way that they talk to students, call upon students, the control that they try to maintain, the comments they

make, they reinforce the status quo. This confuses students. It reinforces the impression that, despite what we read, despite what this guy says, if we really just look carefully at the way he's saying it, who he rewards, how he approaches people, there is no real difference. These actions undermine liberatory pedagogy.

bh: Once again, we are referring to a discussion of whether or not we subvert the classroom's politics of domination simply by using different material, or by having a different, more radical standpoint. Again and again, you and I are saying that different, more radical subject matter does not create a liberatory pedagogy, that a simple practice like including personal experience may be more constructively challenging than simply changing the curriculum. That is why there has been such critique of the place of experience—of confessional narrative—in the classroom. One of the ways you can be written off quickly as a professor by colleagues who are suspicious of progressive pedagogy is to allow your students, or yourself, to talk about experience; sharing personal narratives yet linking that knowledge with academic information really enhances our capacity to know.

RS: When one speaks from the perspective of one's immediate experiences, something's created in the classroom for students, sometimes for the very first time. Focusing on experience allows students to claim a knowledge base from which they can speak.

bh: One of the most misunderstood aspects of my writing on pedagogy is the emphasis on *voice*. Coming to voice is not just the act of telling one's experience. It is using that telling strategically—to come to voice so that you can also speak freely about other subjects. What many professors are frightened of is precisely that. I had a difficult moment last semester at City College in my seminar on Black

Women Writers. At the last class I talked with students about what they had brought individually to the classroom; but when they spoke, they showed me that our class had made them fear taking other classes. They confessed, "You've taught us how to think critically, to challenge, and to confront, and you've encouraged us to have a voice. But how can we go to other classrooms? No one wants us to have a voice in those classrooms!" This is the tragedy of education that does not promote freedom. And repressive education practices are more acceptable at state institutions than at places like Oberlin or Yale. In the privileged liberal arts colleges, it is acceptable for professors to respect the "voice" of any student who wants to make a point. Many students in those institutions feel they are entitled—that their voices deserve to be heard. But students in public institutions, mostly from working-class backgrounds, come to college assuming that professors see them as having nothing of value to say, no valuable contribution to make to a dialectical exchange of ideas.

RS: Sometimes professors may even act as though personal recognition is important, but they do so in a superficial way. Professors, even those who view themselves as liberal, may think that it's good for students to speak, only to proceed in a manner that devalues what the students say.

bh: We're willing to hear Suzie speak even as we then immediately turn away from her words, erasing them. This undermines a pedagogy that seeks constantly to affirm the value of student voices. It suggests a democratic process by which we erase words, and their capacity to influence and affirm. With that erasure Suzie is not able to see herself as a speaking subject worthy of voice. I don't mean only in terms of how she names her personal experience, but how she interrogates both the experiences of others, and how she responds to knowledge presented.

RS: In many classes this comes full circle. In the end it's the
 teacher's voice that everyone knew all along was the only
 one to listen to. And now that we've gone around in a cir-
 cle—an exaggerated thing—we all know that the democ-
 ratic voice, an expression of that voice, leads to a rather
 conservative conclusion. Even though students are speak-
 ing they don't really know how to listen to other students.

bh: In regards to pedagogical practices we must intervene to
 alter the existing pedagogical structure and to teach stu-
 dents *how to listen, how to hear one another.*

RS: So one of the responsibilities of the teacher is to help cre-
 ate an environment where students learn that, in addi-
 tion to speaking, it is important to listen respectfully to
 others. This doesn't mean we listen uncritically or that
 classrooms can be open so that anything someone else
 says is taken as true, but it means really taking seriously
 what someone says. In principle, the classroom ought to
 be a place where things are said seriously—not without
 pleasure, not without joy—but seriously, and for serious
 consideration. I notice many students have difficulty tak-
 ing seriously what they themselves have to say because
 they are convinced that the only person who says any-
 thing of note is the teacher. Even if another student does
 say something that the teacher says is good, helpful,
 smart, whatever, it's only through the act of the teacher's
 validating that the other students take note. If the
 teacher doesn't seem to indicate that this is something
 worth noting, few students will. I see it as a fundamental
 responsibility of the teacher to show by example the abil-
 ity to listen to others seriously. Our focus on student voice
 raises a whole range of questions about silencing. At what
 point does one say what someone else is saying ought not
 to be pursued in the classroom?

bh: One of the reasons I appreciate people linking the personal to the academic is that I think that the more students recognize their own uniqueness and particularity, the more they listen. So, one of my teaching strategies is to redirect their attention away from my voice to one another's voices. I often find that this happens most quickly when students share experiences in conjunction with academic subject matter, because then people remember each other.

Earlier I raised the dilemma that professors who cannot communicate well cannot teach students how to communicate. Many professors who are critical of the inclusion of confessional narrative in the classroom or of digressive discussions, where students are doing a lot of the talking, are critical because they lack the skill needed to facilitate dialogue. Once the space for dialogue is open in the classroom, that moment must be orchestrated so that you don't get bogged down with people who just like to hear themselves talk, or with people who are unable to relate experience to the academic subject matter. At times I need to interrupt students and say, "That's interesting, but how does that relate to the novel we're reading?"

RS: Many people, both students and professors, believe that when they hear people like ourselves talking about encouraging a student's opinion in class we're merely endorsing the stereotypical rap session: everyone says anything they want; there's no real direction or purpose to the class other than making each other feel good; that anything can be said. Yet one can be critical and be respectful at the same time. One can interrupt someone, and still have a serious, respectful dialogue. All too often it is assumed that if you "give students the freedom"—and it's a mistake to think we're talking about giving students

freedom rather than seeing it is a project that teachers and students are working on together—there will be chaos, that no serious discussion will ensue.

bh: That's the difference education as the practice of freedom makes. The bottom-line assumption has to be that everyone in the classroom is able to act responsibly. That has to be the starting point—that we are able to act responsibly together to create a learning environment. All too often we have been trained as professors to assume students are not capable of acting responsibly, that if we don't exert control over them, then there's just going to be mayhem.

RS: Or excess. There is such a fear of letting go in the classroom, of taking risks. When professors let go it is not only the student voice that must speak freely but also the professor's voice. Teachers need to practice freedom, to speak, just as much as students do.

bh: Absolutely. That's a point I keep making in my pedagogy essays over and over again. In much feminist scholarship criticizing critical pedagogy, there is an attack on the notion of the classroom as a space where students are empowered. Yet the classroom should be a space where we're all in power in different ways. That means we professors should be empowered by our interactions with students. In my books I try to show how much my work is influenced by what students say in the classroom, what they do, what they express to me. Along with them I grow intellectually, developing sharper understandings of how to share knowledge and what to do in my participatory role with students. This is one of the primary differences between education as a practice of freedom and the conservative banking system which encourages professors to believe deep down in the core of their being that they have nothing to learn from their students.

RS: And that goes back to your emphasis on engaged peda-
gogy, on commitment. Intellectuals, even radical intellec-
tuals, have to be careful not to reinscribe the very modes
of domination in our practice with students. Using libera-
tory discourse is not enough if we ultimately fall back on
the banking system.

bh: When I enter the classroom at the beginning of the
semester the weight is on me to establish that our pur-
pose is to be, for however brief a time, a community of
learners *together*. It positions me as a learner. But I'm also
not suggesting that I don't have more power. And I'm not
trying to say we're all equal here. I'm trying to say that we
are all equal here to the extent that we are equally com-
mitted to creating a learning context.

RS: That's right. That returns us to the issue of respect. Sure,
it's bad faith to pretend that we're all the same because
the teacher's the one who ultimately is going to grade. In
traditional terms that *is* the source of power, and judging
is something we all do as students and as teachers. That's
not really the source of power in the successful class-
room. The power of the liberatory classroom is in fact
the power of the learning process, the work we do to
establish a community.

bh: Another difficulty I had to work through early on as a
professor was evaluating whether or not our experience
in the classroom had been rewarding. In the classes I
teach, students are often presented with new paradigms
and are being asked to shift their ways of thinking to con-
sider new perspectives. In the past I have often felt that
this type of learning process is very hard; it's painful and
troubling. It may be six months or a year, even two years
later, that they realize the importance of what they have
learned. That was really hard for me, because I think part
of what the banking system does for professors is create

the system where we want to feel that by the end of the
semester every student will be sitting there filling out
their evaluations testifying that I'm a "good teacher." It's
all about feeling good, feeling good about me, and feel-
ing good about the class. But in reconceptualizing en-
gaged pedagogy I had to realize that our purpose here
isn't really to feel good. Maybe we enjoy certain classes,
but it will usually be difficult. We have to learn how to
appreciate difficulty, too, as a stage in intellectual devel-
opment. Or accept that that cozy, good feeling may at
times block the possibility of giving students space to feel
that there is integrity to be found in grappling with diffi-
cult material, whether that material comes from confes-
sional narratives, books, or discussions.

RS: Genuinely radical critical teachers are conscious of this
even though their peers and some students don't fully
appreciate it. Sometimes it's important to remind stu-
dents that joy can be present *along with hard work*. Not
every moment in the classroom will necessarily be one
that brings you immediate pleasure, but that doesn't pre-
clude the possibility of joy. Nor does it deny the reality
that learning can be painful. And sometimes it's neces-
sary to remind students and colleagues that pain and
painful situations don't necessarily translate into harm.
We make that very fundamental mistake all the time. Not
all pain is harm, and not all pleasure is good. Many col-
leagues walk by a class that's engaged and see students
working, see them either in tears, or smiling and laugh-
ing, and assume it's mere emotion.

bh: Or if it's emotional that it's a kind of group therapy. Few
professors talk about the place of emotions in the class-
room. In the introductory chapter of this book I talk
about my longing that the classroom be an exciting
place. If we are all emotionally shut down, how can there

be any excitement about ideas? When we bring our passion to the classroom our collective passions come together, and there is often an emotional response, one that can overwhelm. The restrictive, repressive classroom ritual insists that emotional responses have no place. Whenever emotional responses erupt, many of us believe our academic purpose has been diminished. To me this is really a distorted notion of intellectual practice, since the underlying assumption is that to be truly intellectual we must be cut off from our emotions.

RS: Or, as you pointed out, it's another practice of denial, wherein the full body and soul of a person is not allowed in the classroom.

bh: If we focus not just on whether the emotions produce pleasure or pain, but on how they keep us aware or alert, we are reminded that they enhance classrooms. There are times when I walk into my class and the students seem absolutely bored out of their minds. And I say to them, "What's up? Everybody seems to be really bored today. There seems to be a lack of energy. What should we do? What can we do?" I might say, "Clearly the direction we're moving in doesn't seem to be awakening your senses, your passions right now." My intent is to engage them more fully. Often students want to deny that they are collectively bored. They want to please me. Or they don't want to be critical. At such times I must stress that, "I'm not taking this personally. It's not just my job to make this class work. It's everyone's responsibility." They might reply, "Well it's exam time," or "It's this kind of time," or "It's the beginning of spring," or "We just don't want to be sitting here." And then I try to say, "Well, then, what can we do? How can we approach our subject to make it more interesting?" One of the most intense aspects of liberatory pedagogical practice is the challenge on the part

of the professor to change the set agenda. We all learn to make lesson plans, and want to stick to them. When I began teaching, I would feel panic, a sense of crisis, if there was a deviation from my set agenda. I think the crisis we all feel about changing agendas is the fear that we will not cover enough material. And in thinking this through I have to undermine my own "I"; maybe the material I most want them to know on a given day is not necessarily what learning is about. Professors can dish out all the right material, but if people are not in a mind to receive it, they leave classrooms empty of that information, even though we may feel we've really done our jobs.

RS: To focus on covering material precisely is one way to slip back into a banking system. That often happens when teachers ignore the mood of the class, the mood of the season, even the mood of the building. The simple act of recognizing a mood and asking "What's this about?" can awaken an exciting learning process.

bh: Right. And how we work with that mood or how we cope if we can't work with it.

RS: Right. I remember a very poignant moment for me happened during one class. There had been several disruptions that happened because of problems with scheduling; classes were ending and beginning at odd times. Students were forced to leave one class, go to another. This disruption involved about fifty people. At one point there was a steady stream of people coming into the class, and there were jets flying over the Queens College campus. I looked up and said, "Enough, today. This isn't going to happen unless you guys want to go somewhere else. I can't do anything more. It's not working for me; I'm failing." I asked whether anyone in the class would want to take over, to lead the discussion, but everyone agreed it wasn't working out. Afterwards, people ran after

me asking, "Are you upset? Are you mad at us?" I said, "Not at all; this was like a bad ballgame. You know, it's twelve–nothing in the first inning, and it's raining. Let's call it a day."

bh: That brings us back to grades. Many professors are afraid of allowing nondirected thought in the classroom for fear that deviation from a set agenda will interfere with the grading process. A more flexible grading process must go hand in hand with a transformed classroom. Standards must always be high. Excellence must be valued, but standards cannot be absolute and fixed.

RS: In most of the courses I teach, I take the position that I am observing. I am there to observe and evaluate the work that's being done.

bh: When you acknowledge that we are observers, it means that we are workers in the classroom. To do that work well we can't be simply standing in front of the class reading. If I'm to know whether a student is participating I have to be listening, I have to be recording, and I have to be thinking beyond that moment. I want them to think, "What I'm here for is to work with material, and to work with it the best way that I can. And in doing that I don't have to be fearful about my grade, because if I am working the best I can with this material, I know it's going to be reflected in my grade." I try to communicate that the grade is something they can control by their labor in the classroom.

RS: I think that's a really important point. Many students feel they could never presume to evaluate their own work positively. Someone else will decide how hard or how well they are working. And so there is already a devaluation of their own effort. Our task is to empower students so that they have the skills to assess their academic growth properly.

bh: The obsession with good grades has so much to do with fear of failure. Progressive teaching tries to eradicate that

fear, both in students and in professors. There are moments when I worry that I am not being a "good" teacher, and then I find myself struggling to break with a good/ bad binary. It's more useful for me to think of myself as a progressive teacher who's willing to own both my successes and failures in the classroom.

RS: We often speak of the "good" teacher when we really mean a professor who is engaged fully, deeply with the *art* of teaching.

bh: That makes me think immediately of engaged Buddhism, which can be juxtaposed with more orthodox Buddhism. Engaged Buddhism emphasizes participation and involvement, particularly involvement with a world beyond yourself. "Engaged" is a great way to talk about liberatory classroom practice. It invites us always to be in the present, to remember that the classroom is never the same. Traditional ways of thinking about the classroom stress the opposite paradigm—that the classroom is always the same even when students are different. Sitting around with colleagues at the beginning of the school year, they often complain about this sameness, as though the classroom is inherently a static place. To me, the engaged classroom is always changing. Yet this notion of engagement threatens the institutionalized practices of domination. When the classroom is truly engaged, it's dynamic. It's fluid. It's *always* changing. Last semester, I had a class where when I finished I was walking on air. It had been a *great* class. The students left realizing that they didn't have to think like me, that I wasn't there to reproduce myself. They left with a sense of engagement, with a sense of themselves as critical thinkers, excited about intellectual activity. The semester before that, I had this class that I just hated. I hated it so bad I didn't want to get up in the morning and go to it. I couldn't even sleep at night,

because I hated it so much I feared that I would sleep through it. And it was an 8:00 A.M. class. It didn't work. One of the things that fascinated me about that experience is that we failed to create a learning community in the classroom. That did not mean that individual students didn't learn a great deal, but in terms of creating a communal context for learning, it was a failure. That failure was heartbreaking for me. It was hard to accept that I was not able to control the direction our classroom was moving in. I would think, "What can I do? And what could I have done?" And I kept reminding myself that I couldn't do it alone, that forty other people were also in there.

RS: Much of what we have been saying speaks to our sense of time and temporality in the classroom. When new semesters begin I'm very aware that this is one of the most important moments. No matter that it's a ritual for students—there is also a genuine excitement. At the very beginning of each semester I try to use that excitement to deepen and enrich the classroom experience. I want to tap into that excitement about learning to sustain it, to keep it moving throughout the semester. Engaged teachers know that even in the worst circumstances, people tend to learn. People do tend to learn, but we want more than just learning; it's sort of like saying even under the worst circumstances, people survive; we're not interested in simply surviving here.

bh: Absolutely. That's why "education as the practice of freedom" is a phrase that has always wowed me. Students leave any classroom with information whether the pedagogy has been engaging or not. I remember a class that I took from a professor who was a serious alcoholic. He was a tragic figure, who often came late to the classroom and rambled on, but there was still something to be had from the material. But it was a horrible experience. We became

complicit in his substance abuse each class when we didn't see it. This example makes me think again about ways we see the body, the "self" of the professor. Even though he was stumbling around drunk, giving the same lecture he gave last week, we didn't tell him because we didn't want to disrupt his authority, his image of himself. We didn't break through that denial: we were simply complicit.

RS: Complicity often happens because professors and students alike are afraid to challenge, because that would mean more work. Engaged pedagogy is physically exhausting!

bh: And that's partly about numbers. Even the best, most engaged classroom can fail under the weight of too many people. That's really been a problem for me in my teaching career. As I've become more and more committed to liberatory pedagogical practices, my classrooms have become just too large. So those practices are undermined by sheer numbers. Rebelling against that has meant insisting on limits to classroom size. Overcrowded classes are like overcrowded buildings—the structure can collapse.

RS: Taking up your metaphor of a building, let's say you have someone in the building who's in charge of maintaining it. The person's a great worker and does everything that should be done, meticulously and responsibly. But the owner of the building is simply overcrowding the building to a point where every system in the building—from the sewers to toilets, to the garbage, everything—is just overburdened. This person eventually will be exhausted; and even though an incredible job is being done, the result will be a building that still looks dirty, that looks ill-kept, etc. In terms of the institution, we have to realize that if we are working on ourselves to become more fully engaged, there's only so much that we can do. Ultimately, the institution will exhaust us simply because there is no sustained institutional support for liberatory pedagogical practices.

bh: It's been really troubling to me. The more the engaged classroom becomes overcrowded, the more it is in danger of being a spectacle, a place of entertainment. When that happens, the potentially transformative power of that classroom is undermined, and my commitment to teaching is undermined.

RS: We have to resist being turned into spectacles. That means resisting "star" status, resisting playing the role of performer. One of the disadvantages, I'd say, to your own celebrity might be the attraction of certain people to the classroom to watch, rather than to be engaged. That's a problem in our culture with celebrity itself, but one can refuse to be simply watched.

bh: When we have star status, iconic status as professors, people stop coming to classes solely because they desire participatory education. Some come to see bell hooks perform. Students who come for the "star" that they take to be bell hooks often engage in a sort of self censorship because they want to please me. Or they come to confront me. Ideally, students who want to be "devotees" would come to be transformed by active participation. But the project of creating a learning community as a teacher is difficult enough without this added complication! The classroom is not for stars; it's a place for learning. For me, star status can be diffused by my willingness to inhabit locations where that status does not exist. Let's talk about ways we would alter our profession. I think it would enhance our teaching practices if professors didn't always teach at the same type of institution. Even though I have a radical commitment to teaching, I was very frightened about changing my teaching location. I feared that after teaching in wealthy private schools for so long, and teaching students who've had privileged educational support structures before coming into college, I wouldn't be able

to work as an engaged teacher in a different kind of set-
ting. Coming to teach at City College, a public institution
with many students from nonprivileged backgrounds, was
and is a constant challenge. In the beginning I felt afraid.
That fear reminded me of the need to be able to shift my
thinking, my sense of what I do as a professor. That sense
can be altered by context.

Fixed notions about teaching as a process are continu-
ally challenged in a learning context where students are
really diverse, where they do not share the same assump-
tions about learning. Last semester at City College, I had
fifteen black students in my literature class. Only one of
them was African American. The others were Afro-
Caribbean from many diverse locations. So I had to
change certain assumptions that I might have had about
black experience. The fact that most of these students had
a sense of a home outside the United States that they
could return to—cultures, other places of origin—really
informed their way of reading texts. A factory model of
educational process would not have encouraged a shift in
teaching practices.

RS: We were talking about the disadvantages of celebrity. But
one of the benefits of having a certain kind of recogni-
tion, celebrity, within your profession is that you can
move from institution to institution whereas most profes-
sors are stuck.

bh: That's why I was suggesting that it would be exciting to
create a structure for education where *everybody* could
move. I see the ability of professors to move as essential to
maintaining excitement about their work.

RS: Oh, absolutely. Most people aren't celebrities. Most of us
teach in virtual obscurity. But there are still ways we can
move. We simply have to work at it differently. For exam-
ple, if you are a tenured professor, you can take a leave of

absence, and while you may not make the same money, you could choose different work, different settings.

bh: Other kinds of work in diverse settings might well enhance our capacity to teach. And if I were refashioning our educational system, that would be possible.

RS: Even within the context of a university setting, a person— a teacher, a professor—can say, "What else can I do?" A place like Queens, where I teach, a community of 17,000 people, that's bigger than a lot of towns in America.

bh: Twice the size of Oberlin!

RS: It's 17,000 people, from diverse locations, speaking sixty-six languages. That's a lot of people living different lives. Yet many professors say, "Well, if I were able to do something else I might do it." It raises the question of what it means to be in service. There are other ways in which teachers can be working outside the classroom, yet within the university setting: get a course release, or maybe a total course reduction, and do different programs. Universities have to start recognizing that there's more to the education of a student than merely classroom time.

Most of our students work, and work twenty to forty hours a week. They're not just getting supplementary income for clothing or a trip. So the classroom is just one time frame and one location for teachers to be engaged with students. But there's the whole campus, and there's the community beyond the campus that these students belong to. A teacher could do many different things, be engaged in different ways.

bh: Absolutely. I think of the support groups I've created for students outside the classroom.

RS: There are so many ways we can help establish a learning community. For example, it was very awkward at Queens around the time of the Bensonhurst and Howard Beach incidents, both cases where African Americans were killed

by whites. We have students at Queens from Howard
Beach and Bensonhurst. It seemed appropriate that some
dialogue should begin. What happened was a bunch of
students, some of whom were not in my classes but were
friends of people in my classes, sat around a cafeteria table
and started a discussion. It just grew to a point where we
had a yearlong roundtable about race at Queens College;
it was about violence, it was about respect, it was about
issues of how men treat women—all the issues that were
important. I think this helped create learning communi-
ties in the classroom in a way that was different than if
this dialogue had emerged from a traditional institution-
al framework. I didn't get a course release for doing this.
The students didn't originally get any recognition from
the institution. I did ask my department, "Can we have an
Independent Study?" And we called it "Philosophy of
Race" and that was the Independent Study, so the first
semester was no grade, no nothing; the second semester
was done very much as the first semester, but this time the
students were getting institutional recognition for their
thoughtfulness about this issue. And this wasn't just
another "classroom moved to the cafeteria"! I'm not talk-
ing about the lazy person's notion of what it means to
transgress; you know, "It's a nice day. Let's go outside."
There's something else going on when we create spaces
outside the classroom for serious discussions. So a
teacher need not be a celebrity or a superstar to do dif-
ferent things right where they work. There's more to
their work than just being in the classroom, and every
teacher will tell you, "Yes, grading, going to faculty meet-
ings," and so on. But there *are* other things.

bh: I wish institutions would understand that teachers need
time away from teaching, and that time away from teach-
ing is not always a year sabbatical where you're busting

your ass to write a book, but that time away from teaching might be two years, or three. With the kind of job crisis we're in, and I think if somebody can afford to take a leave without pay for two years or three years, and somebody else can have that job who doesn't have a job—why isn't that encouraged? Many professors are not interested in engaged pedagogy because they fear "burn-out." I've been teaching for almost twenty years and I am right now in my first year leave—an unpaid leave—but it's my first real time off. And I feel the lack of time off has been damaging to my teaching. There has to be a recognition of the way the failing economy is taking jobs. There has to be more of an emphasis on job-sharing and job-switching in the interest of creating an environment where engaged teaching can be sustained.

RS: This idea frightens a lot of teachers. They're worried it will lead to more work, and not different work, and not more excitement and more engagement for them. Engaged teachers are conscious of their own individual lives but also of their involvement with others, but I think traditional teachers take that same sort of recognition and turn it into a right to privacy, so that once tenure is granted there's a real withdrawal. Tenure affords many of us the opportunity to hide.

bh: Which takes us back, finally, to self-actualization. If professors are wounded, damaged individuals, people who are not self-actualized, then they will seek asylum in the academy rather than seek to make the academy a place of challenge, dialectical interchange, and growth.

RS: This is one of the tragedies in education today. We have a lot of people who don't recognize that *being a teacher* is *being with people.*

This page intentionally left blank

11

Language

Teaching New Worlds/New Words

Like desire, language disrupts, refuses to be contained within boundaries. It speaks itself against our will, in words and thoughts that intrude, even violate the most private spaces of mind and body. It was in my first year of college that I read Adrienne Rich's poem, "The Burning of Paper Instead of Children." That poem, speaking against domination, against racism and class oppression, attempts to illustrate graphically that stopping the political persecution and torture of living beings is a more vital issue than censorship, than burning books. One line of this poem that moved and disturbed something within me: "This is the oppressor's language yet I need it to talk to you." I've never forgotten it. Perhaps I could not have forgotten it even if I tried to erase it from memory. Words impose themselves, take root in our memory against our will. The words of this poem begat a life in my memory that I could not abort or change.

When I find myself thinking about language now, these words are there, as if they were always waiting to challenge and assist me. I find myself silently speaking them over and over again with the intensity of a chant. They startle me, shaking me into an awareness of the link between languages and domination. Initially, I resist the idea of the "oppressor's language," certain that this construct has the potential to disempower those of us who are just learning to speak, who are just learning to claim language as a place where we make ourselves subject. *"This is the oppressor's languages yet I need it to talk to you."* Adrienne Rich's words. Then, when I first read these words, and now, they make me think of standard English, of learning to speak against black vernacular, against the ruptured and broken speech of a dispossessed and displaced people. Standard English is not the speech of exile. It is the language of conquest and domination; in the United States, it is the mask which hides the loss of so many tongues, all those sounds of diverse, native communities we will never hear, the speech of the Gullah, Yiddish, and so many other unremembered tongues.

Reflecting on Adrienne Rich's words, I know that it is not the English language that hurts me, but what the oppressors do with it, how they shape it to become a territory that limits and defines, how they make it a weapon that can shame, humiliate, colonize. Gloria Anzaldúa reminds us of this pain in *Borderlands/La Frontera* when she asserts, "So, if you want to really hurt me, talk badly about my language." We have so little knowledge of how displaced, enslaved, or free Africans who came or were brought against their will to the United States felt about the loss of language, about learning English. Only as a woman did I begin to think about these black people in relation to language, to think about their trauma as they were compelled to witness their language rendered meaningless with a colonizing European culture, where voices deemed foreign could not be spoken, were outlawed tongues, renegade speech.

When I realize how long it has taken for white Americans to acknowledge diverse languages of Native Americans, to accept that the speech their ancestral colonizers declared was merely grunts or gibberish was indeed *language*, it is difficult not to hear in standard English always the sound of slaughter and conquest. I think now of the grief of displaced "homeless" Africans, forced to inhabit a world where they saw folks like themselves, inhabiting the same skin, the same condition, but who had no shared language to talk with one another, who needed "the oppressor's language." *"This is the oppressor's language yet I need it to talk to you."* When I imagine the terror of Africans on board slave ships, on auction blocks, inhabiting the unfamiliar architecture of plantations, I consider that this terror extended beyond fear of punishment, that it resided also in the anguish of hearing a language they could not comprehend. The very sound of English had to terrify. I think of black people meeting one another in a space away from the diverse cultures and languages that distinguished them from one another, compelled by circumstance to find ways to speak with one another in a "new world" where blackness or the darkness of one's skin and not language would become the space of bonding. How to remember, to reinvoke this terror. How to describe what it must have been like for Africans whose deepest bonds were historically forged in the place of shared speech to be transported abruptly to a world where the very sound of one's mother tongue had no meaning.

I imagine them hearing spoken English as the oppressor's language, yet I imagine them also realizing that this language would need to be possessed, taken, claimed as a space of resistance. I imagine that the moment they realized the oppressor's language, seized and spoken by the tongues of the colonized, could be a space of bonding was joyous. For in that recognition was the understanding that intimacy could be restored, that a culture of resistance could be formed that would make recov-

ery from the trauma of enslavement possible. I imagine, then,
Africans first hearing English as "the oppressor's language"
and then re-hearing it as a potential site of resistance. Learning
English, learning to speak the alien tongue, was one way en-
slaved Africans began to reclaim their personal power within a
context of domination. Possessing a shared language, black
folks could find again a way to make community, and a means
to create the political solidarity necessary to resist.

Needing the oppressor's language to speak with one anoth-
er they nevertheless also reinvented, remade that language so
that it would speak beyond the boundaries of conquest and
domination. In the mouths of black Africans in the so-called
"New World," English was altered, transformed, and became a
different speech. Enslaved black people took broken bits of
English and made of them a counter-language. They put togeth-
er their words in such a way that the colonizer had to rethink
the meaning of English language. Though it has become com-
mon in contemporary culture to talk about the messages of
resistance that emerged in the music created by slaves, particu-
larly spirituals, less is said about the grammatical construction
of sentences in these songs. Often, the English used in the song
reflected the broken, ruptured world of the slave. When the
slaves sang "nobody knows de trouble I see—" their use of the
word "nobody" adds a richer meaning than if they had used the
phrase "no one," for it was the slave's *body* that was the concrete
site of suffering. And even as emancipated black people sang
spirituals, they did not change the language, the sentence struc-
ture, of our ancestors. For in the incorrect usage of words, in
the incorrect placement of words, was a spirit of rebellion that
claimed language as a site of resistance. Using English in a way
that ruptured standard usage and meaning, so that white folks
could often not understand black speech, made English into
more than the oppressor's language.

An unbroken connection exists between the broken English
of the displaced, enslaved African and the diverse black vernac-
ular speech black folks use today. In both cases, the rupture of
standard English enabled and enables rebellion and resistance.
By transforming the oppressor's language, making a culture of
resistance, black people created an intimate speech that could
say far more than was permissible within the boundaries of stan-
dard English. The power of this speech is not simply that it
enables resistance to white supremacy, but that it also forges a
space for alternative cultural production and alternative epis-
temologies—different ways of thinking and knowing that were
crucial to creating a counter-hegemonic worldview. It is abso-
lutely essential that the revolutionary power of black vernacular
speech not be lost in contemporary culture. That power resides
in the capacity of black vernacular to intervene on the bound-
aries and limitations of standard English.

In contemporary black popular culture, rap music has be-
come one of the spaces where black vernacular speech is used
in a manner that invites dominant mainstream culture to lis-
ten—to hear—and, to some extent, be transformed. However,
one of the risks of this attempt at cultural translation is that it
will trivialize black vernacular speech. When young white kids
imitate this speech in ways that suggest it is the speech of those
who are stupid or who are only interested in entertaining or
being funny, then the subversive power of this speech is under-
mined. In academic circles, both in the sphere of teaching and
that of writing, there has been little effort made to utilize black
vernacular—or, for that matter, any language other than stan-
dard English. When I asked an ethnically diverse group of stu-
dents in a course I was teaching on black women writers why we
only heard standard English spoken in the classroom, they
were momentarily rendered speechless. Though many of them
were individuals for whom standard English was a second or

third language, it had simply never occurred to them that it was possible to say something in another language, in another way. No wonder, then, that we continue to think, "This is the oppressor's language yet I need it to talk to you."

I have realized that I was in danger of losing my relationship to black vernacular speech because I too rarely use it in the predominantly white settings that I am most often in, both professionally and socially. And so I have begun to work at integrating into a variety of settings the particular Southern black vernacular speech I grew up hearing and speaking. It has been hardest to integrate black vernacular in writing, particularly for academic journals. When I first began to incorporate black vernacular in critical essays, editors would send the work back to me in standard English. Using the vernacular means that translation into standard English may be needed if one wishes to reach a more inclusive audience. In the classroom setting, I encourage students to use their first language and translate it so they do not feel that seeking higher education will necessarily estrange them from that language and culture they know most intimately. Not surprisingly, when students in my Black Women Writers class began to speak using diverse language and speech, white students often complained. This seemed to be particularly the case with black vernacular. It was particularly disturbing to the white students because they could hear the words that were said but could not comprehend their meaning. Pedagogically, I encouraged them to think of the moment of not understanding what someone says as a space to learn. Such a space provides not only the opportunity to listen without "mastery," without owning or possessing speech through interpretation, but also the experience of hearing non-English words. These lessons seem particularly crucial in a multicultural society that remains white supremacist, that uses standard English as a weapon to silence and censor. June Jordan reminds us of this in *On Call* when she declares:

I am talking about majority problems of language in a
democratic state, problems of a currency that someone
has stolen and hidden away and then homogenized into
an official "English" language that can only express non-
events involving nobody responsible, or lies. If we lived
in a democratic state our language would have to hurtle,
fly, curse, and sing, in all the common American names,
all the undeniable and representative participating voic-
es of everybody here. We would not tolerate the language
of the powerful and, thereby, lose all respect for words,
per se. We would make our language conform to the
truth of our many selves and we would make our lan-
guage lead us into the equality of power that a democrat-
ic state must represent.

That the students in the course on black women writers
were repressing all longing to speak in tongues other than stan-
dard English without seeing this repression as political was an
indication of the way we act unconsciously, in complicity with a
culture of domination.

Recent discussions of diversity and multiculturalism tend to
downplay or ignore the question of language. Critical feminist
writings focused on issues of difference and voice have made
important theoretical interventions, calling for a recognition
of the primacy of voices that are often silenced, censored, or
marginalized. This call for the acknowledgment and celebra-
tion of diverse voices, and consequently of diverse language
and speech, necessarily disrupts the primacy of standard Eng-
lish. When advocates of feminism first spoke about the desire
for diverse participation in women's movement, there was no
discussion of language. It was simply assumed that standard
English would remain the primary vehicle for the transmission
of feminist thought. Now that the audience for feminist writing
and speaking has become more diverse, it is evident that we
must change conventional ways of thinking about language,
creating spaces where diverse voices can speak in words other

— but is it "broken"??

than English or in (broken,) vernacular speech. This means that at a lecture or even in a written work there will be fragments of speech that may or may not be accessible to every individual. Shifting how we think about language and how we use it necessarily alters how we know what we know. At a lecture where I might use Southern black vernacular, the particular patois of my region, or where I might use very abstract thought in conjunction with plain speech, responding to a diverse audience, I suggest that we do not necessarily need to hear and know what is stated in its entirety, that we do not need to "master" or conquer the narrative as a whole, that we may know in fragments. I suggest that we may learn from spaces of silence as well as spaces of speech, that in the patient act of listening to another tongue we may subvert that culture of capitalist frenzy and consumption that demands all desire must be satisfied immediately, or we may disrupt that cultural imperialism that suggests one is worthy of being heard only if one speaks in standard English.

Adrienne Rich concludes her poem with this statement:

> I am composing on the typewriter late at night, thinking of today. How well we all spoke. A language is a map of our failures. Frederick Douglass wrote an English purer than Milton's. People suffer highly in poverty. There are methods but we do not use them. Joan, who could not read, spoke some peasant form of French. Some of the suffering are: it is hard to tell the truth; this is America; I cannot touch you now. In America we have only the present tense. I am in danger. You are in danger. The burning of a book arouses no sensation in me. I know it hurts to burn. There are flames of napalm in Cantonsville, Maryland. I know it hurts to burn. The typewriter is overheated, my mouth is burning, I cannot touch you and this is the oppressor's language.

To recognize that we touch one another in language seems particularly difficult in a society that would have us believe that

there is no dignity in the experience of passion, that to feel deeply is to be inferior, for within the dualism of Western metaphysical thought, ideas are always more important than language. To heal the splitting of mind and body, we marginalized and oppressed people attempt to recover ourselves and our experiences in language. We seek to make a place for intimacy. Unable to find such a place in standard English, we create the ruptured, broken, unruly speech of the vernacular. When I need to say words that do more than simply mirror or address the dominant reality, I speak black vernacular. There, in that location, we make English do what we want it to do. We take the oppressor's language and turn it against itself. We make our words a counter-hegemonic speech, liberating ourselves in language.

This page intentionally left blank

12

Confronting Class in the Classroom

Class is rarely talked about in the United States; nowhere is there a more intense silence about the reality of class differences than in educational settings. Significantly, class differences are particularly ignored in classrooms. From grade school on, we are all encouraged to cross the threshold of the classroom believing we are entering a democratic space—a free zone where the desire to study and learn makes us all equal. And even if we enter accepting the reality of class differences, most of us still believe knowledge will be meted out in fair and equal proportions. In those rare cases where it is acknowledged that students and professors do not share the same class backgrounds, the underlying assumption is still that we are all equally committed to getting ahead, to moving up the ladder of success to the top. And even though many of us will not make it to the top, the unspoken understanding is that we will land somewhere in the middle, between top and bottom.

Coming from a nonmaterially privileged background, from the working poor, I entered college acutely aware of class.

When I received notice of my acceptance at Stanford University, the first question that was raised in my household was how I would pay for it. My parents understood that I had been awarded scholarships, and allowed to take out loans, but they wanted to know where the money would come from for transportation, clothes, books. Given these concerns, I went to Stanford thinking that class was mainly about materiality. It only took me a short while to understand that class was more than just a question of money, that it shaped values, attitudes, social relations, and the biases that informed the way knowledge would be given and received. These same realizations about class in the academy are expressed again and again by academics from working-class backgrounds in the collection of essays *Strangers in Paradise* edited by Jake Ryan and Charles Sackrey.

During my college years it was tacitly assumed that we all agreed that class should not be talked about, that there would be no critique of the bourgeois class biases shaping and informing pedagogical process (as well as social etiquette) in the classroom. Although no one ever directly stated the rules that would govern our conduct, it was taught by example and reinforced by a system of rewards. As silence and obedience to authority were most rewarded, students learned that this was the appropriate demeanor in the classroom. Loudness, anger, emotional outbursts, and even something as seemingly innocent as unrestrained laughter were deemed unacceptable, vulgar disruptions of classroom social order. These traits were also associated with being a member of the lower classes. If one was not from a privileged class group, adopting a demeanor similar to that of the group could help one to advance. It is still necessary for students to assimilate bourgeois values in order to be deemed acceptable.

Bourgeois values in the classroom create a barrier, blocking the possibility of confrontation and conflict, warding off dissent. Students are often silenced by means of their acceptance

of class values that teach them to maintain order at all costs. When the obsession with maintaining order is coupled with the fear of "losing face," of not being thought well of by one's professor and peers, all possibility of constructive dialogue is undermined. Even though students enter the "democratic" classroom believing they have the right to "free speech," most students are not comfortable exercising this right to "free speech." Most students are not comfortable exercising this right—especially if it means they must give voice to thoughts, ideas, feelings that go against the grain, that are unpopular. This censoring process is only one way bourgeois values overdetermine social behavior in the classroom and undermine the democratic exchange of ideas. Writing about his experience in the section of *Strangers in Paradise* entitled "Outsiders," Karl Anderson confessed:

> Power and hierarchy, and not teaching and learning, dominated the graduate school I found myself in. "Knowledge" was one-upmanship, and no one disguised the fact. . . . The one thing I learned absolutely was the inseparability of free speech and free thought. I, as well as some of my peers, were refused the opportunity to speak and sometimes to ask questions deemed "irrelevant" when the instructors didn't wish to discuss or respond to them.

Students who enter the academy unwilling to accept without question the assumptions and values held by privileged classes tend to be silenced, deemed troublemakers.

Conservative discussions of censorship in contemporary university settings often suggest that the absence of constructive dialogue, enforced silencing, takes place as a by-product of progressive efforts to question canonical knowledge, critique relations of domination, or subvert bourgeois class biases. There is little or no discussion of the way in which the attitudes

and values of those from materially privileged classes are imposed upon everyone via biased pedagogical strategies. Reflected in choice of subject matter and the manner in which ideas are shared, these biases need never be overtly stated. In his essay Karl Anderson states that silencing is "the most oppressive aspect of middle-class life." He maintains:

> It thrives upon people keeping their mouths shut, unless they are actually endorsing whatever powers exist. The free marketplace of "ideas" that is so beloved of liberals is as much a fantasy as a free marketplace in oil or automobiles; a more harmful fantasy, because it breeds even more hypocrisy and cynicism. Just as teachers can control what is said in their classrooms, most also have ultra-sensitive antennae as to what will be rewarded or punished that is said outside them. And these antennae control them.

Silencing enforced by bourgeois values is sanctioned in the classroom by everyone.

Even those professors who embrace the tenets of critical pedagogy (many of whom are white and male) still conduct their classrooms in a manner that only reinforces bourgeois models of decorum. At the same time, the subject matter taught in such classes might reflect professorial awareness of intellectual perspectives that critique domination, that emphasize an understanding of the politics of difference, of race, class, gender, even though classroom dynamics remain conventional, business as usual. When contemporary feminist movement made its initial presence felt in the academy there was both an ongoing critique of conventional classroom dynamics and an attempt to create alternative pedagogical strategies. However, as feminist scholars endeavored to make Women's Studies a discipline administrators and peers would respect, there was a shift in perspective.

Significantly, feminist classrooms were the first spaces in the university where I encountered any attempt to acknowledge class difference. The focus was usually on the way class differences are structured in the larger society, not on our class position. Yet the focus on gender privilege in patriarchal society often meant that there was a recognition of the ways women were economically disenfranchised and therefore more likely to be poor or working class. Often, the feminist classroom was the only place where students (mostly female) from materially disadvantaged circumstances would speak from that class positionality, acknowledging both the impact of class on our social status as well as critiquing the class biases of feminist thought.

When I first entered university settings I felt estranged from this new environment. Like most of my peers and professors, I initially believed those feelings were there because of differences in racial and cultural background. However, as time passed it was more evident that this estrangement was in part a reflection of class difference. At Stanford, I was often asked by peers and professors if I was there on a scholarship. Underlying this question was the implication that receiving financial aid "diminished" one in some way. It was not just this experience that intensified my awareness of class difference, it was the constant evocation of materially privileged class experience (usually that of the middle class) as a universal norm that not only set those of us from working-class backgrounds apart but effectively excluded those who were not privileged from discussions, from social activities. To avoid feelings of estrangement, students from working-class backgrounds could assimilate into the mainstream, change speech patterns, points of reference, drop any habit that might reveal them to be from a nonmaterially privileged background.

Of course I entered college hoping that a university degree would enhance my class mobility. Yet I thought of this solely in

economic terms. Early on I did not realize that class was much more than one's economic standing, that it determined values, standpoint, and interests. It was assumed that any student coming from a poor or working-class background would willingly surrender all values and habits of being associated with this background. Those of us from diverse ethnic/racial backgrounds learned that no aspect of our vernacular culture could be voiced in elite settings. This was especially the case with vernacular language or a first language that was not English. To insist on speaking in any manner that did not conform to privileged class ideals and mannerisms placed one always in the position of interloper.

Demands that individuals from class backgrounds deemed undesirable surrender all vestiges of their past create psychic turmoil. We were encouraged, as many students are today, to betray our class origins. Rewarded if we chose to assimilate, estranged if we chose to maintain those aspects of who we were, some were all too often seen as outsiders. Some of us rebelled by clinging to exaggerated manners and behavior clearly marked as outside the accepted bourgeois norm. During my student years, and now as a professor, I see many students from "undesirable" class backgrounds become unable to complete their studies because the contradictions between the behavior necessary to "make it" in the academy and those that allowed them to be comfortable at home, with their families and friends, are just too great.

Often, African Americans are among those students I teach from poor and working-class backgrounds who are most vocal about issues of class. They express frustration, anger, and sadness about the tensions and stress they experience trying to conform to acceptable white, middle-class behaviors in university settings while retaining the ability to "deal" at home. Sharing strategies for coping from my own experience, I encourage students to reject the notion that they must choose

between experiences. They must believe they can inhabit comfortably two different worlds, but they must make each space one of comfort. They must creatively invent ways to cross borders. They must believe in their capacity to alter the bourgeois settings they enter. All too often, students from nonmaterially privileged backgrounds assume a position of passivity—they behave as victims, as though they can only be acted upon against their will. Ultimately, they end up feeling they can only reject or accept the norms imposed upon them. This either/or often sets them up for disappointment and failure.

Those of us in the academy from working-class backgrounds are empowered when we recognize our own agency, our capacity to be active participants in the pedagogical process. This process is not simple or easy: it takes courage to embrace a vision of wholeness of being that does not reinforce the capitalist version that suggests that one must always give something up to gain another. In the introduction to the section of their book titled "Class Mobility and Internalized Conflict," Ryan and Sackrey remind readers that "the academic work process is essentially antagonistic to the working class, and academics for the most part live in a different world of culture, different ways that make it, too, antagonistic to working class life." Yet those of us from working-class backgrounds cannot allow class antagonism to prevent us from gaining knowledge, degrees and enjoying the aspects of higher education that are fulfilling. Class antagonism can be constructively used, not made to reinforce the notion that students and professors from working-class backgrounds are "outsiders" and "interlopers," but to subvert and challenge the existing structure.

When I entered my first Women's Studies classes at Stanford, white professors talked about "women" when they were making the experience of materially privileged white women a norm. It was both a matter of personal and intellectual integrity for me to challenge this biased assumption. By challenging, I

refused to be complicit in the erasure of black and/or working-class women of all ethnicities. Personally, that meant I was not able just to sit in class, grooving on the good feminist vibes—that was a loss. The gain was that I was honoring the experience of poor and working-class women in my own family, in that very community that had encouraged and supported me in my efforts to be better educated. Even though my intervention was not wholeheartedly welcomed, it created a context for critical thinking, for dialectical exchange.

Any attempt on the part of individual students to critique the bourgeois biases that shape pedagogical process, particularly as they relate to epistemological perspectives (the points from which information is shared) will, in most cases, no doubt, be viewed as negative and disruptive. Given the presumed radical or liberal nature of early feminist classrooms, it was shocking to me to find those settings were also often closed to different ways of thinking. While it was acceptable to critique patriarchy in that context, it was not acceptable to confront issues of class, especially in ways that were not simply about the evocation of guilt. In general, despite their participation in different disciplines and the diversity of class backgrounds, African American scholars and other nonwhite professors have been no more willing to confront issues of class. Even when it became more acceptable to give at least lip service to the recognition of race, gender, and class, most professors and students just did not feel they were able to address class in anything more than a simplistic way. Certainly, the primary area where there was the possibility of meaningful critique and change was in relation to biased scholarship, work that used the experiences and thoughts of materially privileged people as normative.

In recent years, growing awareness of class differences in progressive academic circles has meant that students and professors committed to critical and feminist pedagogy have the opportunity to make spaces in the academy where class can

receive attention. Yet there can be no intervention that challenges the status quo if we are not willing to interrogate the way our presentation of self as well as our pedagogical process is often shaped by middle-class norms. My awareness of class has been continually reinforced by my efforts to remain close to loved ones who remain in materially underprivileged class positions. This has helped me to employ pedagogical strategies that create ruptures in the established order, that promote modes of learning which challenge bourgeois hegemony.

One such strategy has been the emphasis on creating in classrooms learning communities where everyone's voice can be heard, their presence recognized and valued. In the section of *Strangers in Paradise* entitled "Balancing Class Locations," Jane Ellen Wilson shares the way an emphasis on personal voice strengthened her.

> Only by coming to terms with my own past, my own background, and seeing that in the context of the world at large, have I begun to find my true voice and to understand that, since it is my own voice, that no pre-cut niche exists for it; that part of the work to be done is making a place, with others, where my and our voices, can stand clear of the background noise and voice our concerns as part of a larger song.

When those of us in the academy who are working class or from working-class backgrounds share our perspectives, we subvert the tendency to focus only on the thoughts, attitudes, and experiences of those who are materially privileged. Feminist and critical pedagogy are two alternative paradigms for teaching which have really emphasized the issue of coming to voice. That focus emerged as central, precisely because it was so evident that race, sex, and class privilege empower some students more than others, granting "authority" to some voices more than others.

A distinction must be made between a shallow emphasis on coming to voice, which wrongly suggests there can be some democratization of voice wherein everyone's words will be given equal time and be seen as equally valuable (often the model applied in feminist classrooms), and the more complex recognition of the uniqueness of each voice and a willingness to create spaces in the classroom where all voices can be heard because all students are free to speak, knowing their presence will be recognized and valued. This does not mean that anything can be said, no matter how irrelevant to classroom subject matter, and receive attention—or that something meaningful takes place if everyone has equal time to voice an opinion. In the classes I teach, I have students write short paragraphs that they read aloud so that we all have a chance to hear unique perspectives and we are all given an opportunity to pause and listen to one another. Just the physical experience of hearing, of listening intently, to each particular voice strengthens our capacity to learn together. Even though a student may not speak again after this moment, that student's presence has been acknowledged.

Hearing each other's voices, individual thoughts, and sometimes associating theses voices with personal experience makes us more acutely aware of each other. That moment of collective participation and dialogue means that students and professor respect—and here I invoke the root meaning of the word, "to look at"—each other, engage in acts of recognition with one another, and do not just talk to the professor. Sharing experiences and confessional narratives in the classroom helps establish communal commitment to learning. These narrative moments usually are the space where the assumption that we share a common class background and perspective is disrupted. While students may be open to the idea that they do not all come from a common class background, they may still expect that the values of materially privileged groups will be the class's norm.

Some students may feel threatened if awareness of class dif-

ference leads to changes in the classroom. Today's students all dress alike, wearing clothes from stores such as the Gap and Benetton; this acts to erase the markers of class difference that older generations of students experienced. Young students are more eager to deny the impact of class and class differences in our society. I have found that students from upper- and middle-class backgrounds are disturbed if heated exchange takes place in the classroom. Many of them equate loud talk or interruptions with rude and threatening behavior. Yet those of us from working-class backgrounds may feel that discussion is deeper and richer if it arouses intense responses. In class, students are often disturbed if anyone is interrupted while speaking, even though outside class most of them are not threatened. Few of us are taught to facilitate heated discussions that may include useful interruptions and digressions, but it is often the professor who is most invested in maintaining order in the classroom. Professors cannot empower students to embrace diversities of experience, standpoint, behavior, or style if our training has disempowered us, socialized us to cope effectively only with a single mode of interaction based on middle-class values.

Most progressive professors are more comfortable striving to challenge class biases through the material studied than they are with interrogating how class biases shape conduct in the classroom and transforming their pedagogical process. When I entered my first classroom as a college professor and a feminist, I was deeply afraid of using authority in a way that would perpetuate class elitism and other forms of domination. Fearful that I might abuse power, I falsely pretended that no power difference existed between students and myself. That was a mistake. Yet it was only as I began to interrogate my fear of "power" —the way that fear was related to my own class background where I had so often seen those with class power coerce, abuse, and dominate those without—that I began to understand that power was not itself negative. It depended what one did with it.

It was up to me to create ways within my professional power constructively, precisely because I was teaching in institutional structures that affirm it is fine to use power to reinforce and maintain coercive hierarchies.

Fear of losing control in the classroom often leads individual professors to fall into a conventional teaching pattern wherein power is used destructively. It is this fear that leads to collective professorial investment in bourgeois decorum as a means of maintaining a fixed notion of order, of ensuring that the teacher will have absolute authority. Unfortunately, this fear of losing control shapes and informs the professorial pedagogical process to the extent that it acts a barrier preventing any constructive grappling with issues of class.

Sometimes students who want professors to grapple with class differences often simply desire that individuals from less materially privileged backgrounds be given center stage so that an inversion of hierarchical structures takes place, not a disruption. One semester, a number of black female students from working-class backgrounds attended a course I taught on African American women writers. They arrived hoping I would use my professorial power to decenter the voices of privileged white students in nonconstructive ways so that those students would experience what it is like to be an outsider. Some of these black students rigidly resisted attempts to involve the others in an engaged pedagogy where space is created for everyone. Many of the black students feared that learning new terminology or new perspectives would alienate them from familiar social relations. Since these fears are rarely addressed as part of progressive pedagogical process, students caught in the grip of such anxiety often sit in classes feeling hostile, estranged, refusing to participate. I often face students who think that in my classes they will "naturally" not feel estranged and that part of this feeling of comfort, or being "at home," is that they will not have to work as hard as they do in other classes.

[handwritten margin note: How do we change students who have been academically socialized to this environment and behavior?]

These students are not expecting to find alternative pedagogy in my classes but merely "rest" from the negative tensions they may feel in the majority of other courses. It is my job to address these tensions.

If we can trust the demographics, we must assume that the academy will be full of students from diverse classes, and that more of our students than ever before will be from poor and working-class backgrounds. This change will not be reflected in the class background of professors. In my own experience, I encounter fewer and fewer academics from working-class backgrounds. Our absence is no doubt related to the way class politics and class struggle shapes who will receive graduate degrees in our society. However, constructively confronting issues of class is not simply a task for those of us who came from working-class and poor backgrounds; it is a challenge for all professors. Critiquing the way academic settings are structured to reproduce class hierarchy, Jake Ryan and Charles Sackrey emphasize "that no matter what the politics or ideological stripe of the individual professor, of what the content of his or her teaching, Marxist, anarchist, or nihilist, he or she nonetheless participates in the reproduction of the cultural and class relations of capitalism." Despite this bleak assertion they are willing to acknowledge that "nonconformist intellectuals can, through research and publication, chip away with some success at the conventional orthodoxies, nurture students with comparable ideas and intentions, or find ways to bring some fraction of the resources of the university to the service of the . . . class interests of the workers and others below." Any professor who commits to engaged pedagogy recognizes the importance of constructively confronting issues of class. That means welcoming the opportunity to alter our classroom practices creatively so that the democratic ideal of education for everyone can be realized.

13

Eros, Eroticism, and the Pedagogical Process

Professors rarely speak of the place of eros or the erotic in our classrooms. Trained in the philosophical context of Western metaphysical dualism, many of us have accepted the notion that there is a split between the body and the mind. Believing this, individuals enter the classroom to teach as though only the mind is present, and not the body. To call attention to the body is to betray the legacy of repression and denial that has been handed down to us by our professorial elders, who have been usually white and male. But our nonwhite elders were just as eager to deny the body. The predominantly black college has always been a bastion of repression. The public world of institutional learning was a site where the body had to be erased, go unnoticed. When I first became a teacher and needed to use the restroom in the middle of class, I had no clue as to what my elders did in such situations. No one talked about the body in relation to teaching. What did one do with the body in the

classroom? Trying to remember the bodies of my professors, I find myself unable to recall them. I hear voices, remember fragmented details, but very few whole bodies.

Entering the classroom determined to erase the body and give ourselves over more fully to the mind, we show by our beings how deeply we have accepted the assumption that passion has no place in the classroom. Repression and denial make it possible for us to forget and then desperately seek to recover ourselves, our feelings, our passions in some private place—after class. I remember reading an article in *Psychology Today* years ago when I was still an undergraduate, reporting a study which revealed that every so many seconds while giving lectures many male professors were thinking about sexuality —were even having lustful thoughts about students. I was amazed. After reading this article, which as I recall was shared and talked about endlessly in the dormitory, I watched male professors differently, trying to connect the fantasies I imagined them having in their minds with lectures, with their bodies that I had so faithfully learned to pretend I did not see. During my first semester of college teaching, there was a male student in my class whom I always seemed to see and not see at the same time. At one point in the middle of the semester, I received a call from a school therapist who wanted to speak with me about the way I treated this student in the class. The therapist told me that the students had said I was unusually gruff, rude, and downright mean when I related to him. I did not know exactly who the student was, could not put a face or body with his name, but later when he identified himself in class, I realized that I was erotically drawn to this student. And that my naive way of coping with feelings in the classroom that I had been taught never to have was to deflect (hence my harsh treatment of him), repress, and deny. Overly conscious then about ways such repression and denial could lead to the

"wounding" of students, I was determined to face whatever passions were aroused in the classroom setting and deal with them.

Writing about Adrienne Rich's work, connecting it to the work of men who thought critically about the body, in her introduction to *Thinking Through the Body*, Jane Gallop comments:

> Men who do find themselves in some way thinking through the body are more likely to be recognized as serious thinkers and heard. Women have first to prove that we are thinkers, which is easier when we conform to the protocol that deems serious thought separate from an embodied subject in history. Rich is asking women to enter the realms of critical thought and knowledge without becoming disembodied spirit, universal man.

Beyond the realm of critical thought, it is equally crucial that we learn to enter the classroom "whole" and not as "disembodied spirit." In the heady early days of Women's Studies classes at Stanford University, I learned by the example of daring, courageous woman professors (particularly Diane Middlebrook) that there was a place for passion in the classroom, that eros and the erotic did not need to be denied for learning to take place. One of the central tenets of feminist critical pedagogy has been the insistence on not engaging the mind/body split. This is one of the underlying beliefs that has made Women's Studies a subversive location in the academy. While women's studies over the years has had to fight to be taken seriously by academics in traditional disciplines, those of us who have been intimately engaged as students or teachers with feminist thinking have always recognized the legitimacy of a pedagogy that dares to subvert the mind/body split and allow us to be whole in the classroom, and as a consequence wholehearted.

Recently, Susan B., a colleague and friend, whom I taught in

a Women's Studies class when she was an undergraduate, stat-
ed in conversation that she felt she was having so much trouble
with her graduate courses because she has to come to expect a
quality of passionate teaching that is not present where she is
studying. Her comments made me think anew about the place
of passion, of erotic recognition in the classroom setting be-
cause I believe that the energy she felt in our Women's Studies
classes was there because of the extent to which women profes-
sors teaching those courses dared to give fully of ourselves,
going beyond the mere transmission of information in lec-
tures. Feminist education for critical consciousness is rooted in
the assumption that knowledge and critical thought done in
the classroom should inform our habits of being and ways of
living outside the classroom. Since so many of our early classes
were taken almost exclusively by female students, it was easier
for us to not be disembodied spirits in the classroom. Con-
currently, it was expected that we would bring a quality of care
and even "love" to our students. Eros was present in our class-
rooms, as a motivating force. As critical pedagogues we were
teaching students ways to think differently about gender,
understanding fully that this knowledge would also lead them
to live differently.

To understand the place of eros and eroticism in the class-
room, we must move beyond thinking of those forces solely in
terms of the sexual, though that dimension need not be denied.
Sam Keen, in his book *The Passionate Life*, urges readers to
remember that in its earliest conception "erotic potency was not
confined to sexual power but included the moving force that
propelled every life-form from a state of mere potentiality to
actuality." Given that critical pedagogy seeks to transform con-
sciousness, to provide students with ways of knowing that enable
them to know themselves better and live in the world more fully,
to some extent it must rely on the presence of the erotic in the
classroom to aid the learning process. Keen continues:

When we limit "erotic" to its sexual meaning, we betray
our alienation from the rest of nature. We confess that
we are not motivated by anything like the mysterious
force that moves birds to migrate or dandelions to
spring. Furthermore, we imply that the fulfillment or
potential toward which we strive is sexual—the roman-
tic-genital connection between two persons.

Understanding that eros is a force that enhances our overall
effort to be self-actualizing, that it can provide an epistemolog-
ical grounding informing how we know what we know, enables
both professors and students to use such energy in a classroom
setting in ways that invigorate discussion and excite the critical
imagination.

Suggesting that this culture lacks a "vision or science of hy-
geology" (health and well-being) Keen asks: "What forms of
passion might make us whole? To what passions may we surren-
der with the assurance that we will expand rather than dimin-
ish the promise of our lives?" The quest for knowledge that
enables us to unite theory and practice is one such passion. To
the extent that professors bring this passion, which has to be
fundamentally rooted in a love for ideas we are able to inspire,
the classroom becomes a dynamic place where transformations
in social relations are concretely actualized and the false di-
chotomy between the world outside and the inside world of the
academy disappears. In many ways this is frightening. Nothing
about the way I was trained as a teacher really prepared me to
witness my students transforming themselves.

It was during the years that I taught in the African American
Studies department at Yale (a course on black women writers)
that I witnessed the way education for critical consciousness
can fundamentally alter our perceptions of reality and our
actions. During one course we collectively explored in fiction
the power of internalized racism, seeing how it was described
in the literature as well as critically interrogating our experi-

ences. However, one of the black female students who had
always straightened her hair because she felt deep down that
she would not look good if it were not processed—were worn
"natural"—changed. She came to class after a break and told
everyone that this class had deeply affected her, so much so
that when she went to get her usual "perm" some force within
said no. I still remember the fear I felt when she testified that
the class had changed her. Though I believed deeply in the phi-
losophy of education for critical consciousness that empowers,
I had not yet comfortably united theory with practice. Some
small part of me still wanted us to remain disembodied spirits.
And her body, her presence, her changed look was a direct
challenge that I had to face and affirm. She was teaching me.
Now, years later, I read again her final words to the class and
recognize the passion and beauty of her will to know and to act:

> I am a black woman. I grew up in Shaker Heights,
> Ohio. I cannot go back and change years of believing
> that I could never be quite as pretty or intelligent as
> many of my white friends—but I can go forward learn-
> ing pride in who I am. . . . I cannot go back and change
> years of believing that the most wonderful thing in the
> world would be to be Martin Luther King, Jr.'s wife—
> but I can go on and find the strength I need to be the
> revolutionary for myself rather than the companion
> and help for someone else. So no, I don't believe that
> we change what has already been done but we can
> change the future and so I am reclaiming and learning
> more of who I am so that I can be whole.

Attempting to gather my thoughts on eroticism and pedagogy,
I have reread student journals covering a span of ten years.
Again and again, I read notes that could easily be considered
"romantic" as students express their love for me, our class.
Here an Asian student offers her thoughts about a class:

White people have never understood the beauty of silence, of connection and reflection. You teach us to speak, and to listen for the signs of the wind. Like a guide, you walk silently through the forest ahead of us. In the forest everything has sound, speaks . . . You too teach us to talk, where all life speaks in the forest, not just the white man's. Isn't that part of feeling whole—the ability to be able to talk, to not have to be silent or performing all the time, to be able to be critical and honest—openly? This is the truth you have taught us: all people deserve to speak.

Or a black male student writing that he will "love me now and always" because our class has been a dance, and he loves to dance:

I love to dance. When I was a child, I danced everywhere. Why walk there when you can shuffle-ball-change all the way. When I danced my soul ran free. I was poetry. On my Saturday grocery excursions with my mother, I would flap, flap, flap, ball change the shopping cart through the aisles. Mama would turn to me and say, "Boy, stop that dancing. White people think that's all we can do anyway." I would stop but when she wasn't looking I would do a quick high bell kick or tow. I didn't care what white people thought, I just loved to dance-dance-dance. I still dance and I still don't care what people think white or black. When I dance my soul is free. It is sad to read about men who stop dancing, who stop being foolish, who stop letting their souls fly free. . . . I guess for me, surviving whole means never to stop dancing.

These words were written by O'Neal LaRon Clark in 1987. We had a passionate teacher/student relationship. He was taller than six feet; I remember the day he came to class late and came right up to the front, picked me up and whirled me around.

The class laughed. I called him "fool" and laughed. It was by way
of apologizing for being late, for missing any moment of class-
room passion. And so he brought his own moment. I, too, love
to dance. And so we danced our way into the future as comrades
and friends bound by all we had learned in class together.
Those who knew him remember the times he came to class early
to do funny imitations of the teacher. He died unexpectedly last
year—still dancing, still loving me now and always.

When eros is present in the classroom setting, then love is
bound to flourish. Well-learned distinctions between public
and private make us believe that love has no place in the class-
room. Even though many viewers could applaud a movie like
The Dead Poets Society, possibly identifying with the passion of
the professor and his students, rarely is such passion institu-
tionally affirmed. Professors are expected to publish, but no
one really expects or demands of us that we really care about
teaching in uniquely passionate and different ways. Teachers
who love students and are loved by them are still "suspect" in
the academy. Some of the suspicion is that the presence of feel-
ings, of passions, may not allow for objective consideration of
each student's merit. But this very notion is based on the false
assumption that education is neutral, that there is some "even"
emotional ground we stand on that enables us to treat every-
one equally, dispassionately. In reality, special bonds between
professors and students have always existed, but traditionally
they have been exclusive rather than inclusive. To allow one's
feeling of care and will to nurture particular individuals in the
classroom—to expand and embrace everyone—goes against
the notion of privatized passion. In student journals from vari-
ous classes I have taught there have always been complaints
about the perceived special bonding between myself and par-
ticular students. Realizing that my students were uncertain
about expresssions of care and love in the classroom, I found it
necessary to teach on the subject. I asked students once: "Why

do you feel that the regard I extend to a particular student cannot also be extended to each of you? Why do you think there is not enough love or care to go around?" To answer these questions they had to think deeply about the society we live in, how we are taught to compete with one another. They had to think about capitalism and how it informs the way we think about love and care, the way we live in our bodies, the way we try to separate mind from body.

There is not much passionate teaching or learning taking place in higher education today. Even when students are desperately yearning to be touched by knowledge, professors still fear the challenge, allow their worries about losing control to override their desires to teach. Concurrently, those of us who teach the same old subjects in the same old ways are often inwardly bored—unable to rekindle passions we may have once felt. If, as Thomas Merton suggests in his essay on pedagogy "Learning to Live," the purpose of education is to show students how to define themselves "authentically and spontaneously in relation" to the world, then professors can best teach if we are self-actualized. Merton reminds us that "the original and authentic 'paradise' idea, both in the monastery and in the university, implied not simply a celestial store of theoretic ideas to which the Magistri and Doctores held the key, but the inner self of the student" who would discover the ground of their being in relation to themselves, to higher powers, to community. That the "fruit of education . . . was in the activation of that utmost center." To restore passion to the classroom or to excite it in classrooms where it has never been, professors must find again the place of eros within ourselves and together allow the mind and body to feel and know desire.

14

Ecstasy

Teaching and Learning Without Limits

On a gorgeous Maine summer day, I fell down a hill and broke my wrist severely. As I was sitting in the dirt, experiencing the most excruciating pain, more intense than any I had ever felt in my life, an image flashed across the screen of my mind. It was one of me as a young girl falling down another hill. In both cases, my falling was related to challenging myself to move beyond limits. As a child it was the limits of fear. As a grown woman, it was the limits of being tired—what I call "bone weary." I had came to Skowhegan to give a lecture at a summer art program. A number of nonwhite students had shared with me that they rarely have any critique of their work from scholars and artists of color. Even though I felt tired and very sick, I wanted to affirm their work and their needs, so I awakened early in the morning to climb the hill to do studio visits.

Skowhegan was once a working farm. Old barns had been converted into studios. The studio I was leaving, after having

had an intense discussion with several young black artists, female and male, led into a cow pasture. Sitting in pain at the bottom of the hill, staring in the face of the black female artist whose studio door I had been trying to reach, I saw such disappointment. When she came to help me, she expressed concern, yet what I heard was another feeling entirely. She really needed to talk about her work with someone she could trust, who would not approach it with racist, sexist, or classist prejudice, someone whose intellect and vision she could respect. That someone did not need to be me. It could have been any teacher. When I think about my life as a student, I can remember vividly the faces, gestures, habits of being of all the individual teachers who nurtured and guided me, who offered me an opportunity to experience joy in learning, who made the classroom a space of critical thinking, who made the exchange of information and ideas a kind of ecstasy.

Recently, I worked on a program at CBS on American feminism. I and other black women present were asked to name what we felt helps enable feminist thinking and feminist movement. I answered that to me "critical thinking" was the primary element allowing the possibility of change. Passionately insisting that no matter what one's class, race, gender, or social standing, I shared my beliefs that without the capacity to think critically about our selves and our lives, none of us would be able to move forward, to change, to grow. In our society, which is so fundamentally anti-intellectual, critical thinking is not encouraged. Engaged pedagogy has been essential to my development as an intellectual, as a teacher/professor because the heart of this approach to learning is critical thinking. Conditions of radical openness exist in any learning situation where students and teachers celebrate their abilities to think critically, to engage in pedagogical praxis.

Profound commitment to engaged pedagogy is taxing to the spirit. After twenty years of teaching, I have begun to need

time away from the classroom. Somehow, moving around to teach at different institutions has always prevented me from having that marvelous paid sabbatical that is one of the material rewards of academic life. This factor, coupled with commitment to teaching, has meant that even when I take a job that places me on a part-time schedule, instead of taking time away from teaching, I lecture elsewhere. I do this because I sense such desperate need in students—their fear that no one really cares whether they learn or develop intellectually.

My commitment to engaged pedagogy is an expression of political activism. Given that our educational institutions are so deeply invested in a banking system, teachers are more rewarded when we do not teach against the grain. The choice to work against the grain, to challenge the status quo, often has negative consequences. And that is part of what makes that choice one that is not politically neutral. In colleges and universities, teaching is often the least valued of our many professional tasks. It saddens me that colleagues are often suspicious of teachers whom students long to study with. And there is a tendency to undermine the professorial commitment of engaged pedagogues by suggesting that what we do is not as rigorously academic as it should be. Ideally, education should be a place where the need for diverse teaching methods and styles would be valued, encouraged, seen as essential to learning. Occasionally students feel concerned when a class departs from the banking system. I remind them that they can have a lifetime of classes that reflect conventional norms.

Of course, I hope that more professors will seek to be engaged. Although it is a reward of engaged pedagogy that students seek courses with those of us who have made a wholehearted commitment to education as the practice of freedom, it is also true that we are often overworked, our classes often overcrowded. For years, I envied those professors who taught more conventionally, because they frequently had small class-

es. Throughout my teaching career my classes have been too large to be as effective as they could be. Over time, I've begun to see that departmental pressure on "popular" professors to accept larger classes was also a way to undermine engaged pedagogy. If classes became so full that it is impossible to know students' names, to spend quality time with each of them, then the effort to build a learning community fails. Throughout my teaching career, I have found it helpful to meet with each student in my classes, if only briefly. Rather than sitting in my office for hours waiting for individual students to choose to meet or for problems to arise, I have preferred to schedule lunches with students. Sometimes, the whole class might bring lunch and have discussion in a space other than our usual classroom. At Oberlin, for instance, we might go as a class to the African Heritage House and have lunch, both to learn about different places on campus and gather in a setting other than our classroom.

Many professors remain unwilling to be involved with any pedagogical practices that emphasize mutual participation between teacher and student because more time and effort are required to do this work. Yet some version of engaged pedagogy is really the only type of teaching that truly generates excitement in the classroom, that enables students and professors to feel the joy of learning.

I was reminded of this during my trip to the emergency room after falling down that hill. I talked so intensely about ideas with the two students who were rushing me to the hospital that I forgot my pain. It is this passion for ideas, for critical thinking and dialogical exchange that I want to celebrate in the classroom, to share with students.

Talking about pedagogy, thinking about it critically, is not the intellectual work that most folks think is hip and cool. Cultural criticism and feminist theory are the areas of my work that are most often deemed interesting by students and

colleagues alike. Most of us are not inclined to see discussion of pedagogy as central to our academic work and intellectual growth, or the practice of teaching as work that enhances and enriches scholarship. Yet it has been the mutual interplay of thinking, writing and sharing ideas as an intellectual and teacher that creates whatever insights are in my work. My devotion to that interplay keeps me teaching in academic settings, despite their difficulties.

When I first read *Strangers in Paradise: Academics from the Working Class,* I was stunned by the intense bitterness expressed in the individual narratives. This bitterness was not unfamiliar to me. I understood what Jane Ellen Wilson meant when she declared, "The whole process of becoming highly educated was for me a process of losing faith." I have felt that bitterness most keenly in relation to academic colleagues. It emerged from my sense that so many of them willingly betrayed the promise of intellectual fellowship and radical openness that I believe is the heart and soul of learning. When I moved beyond those feelings to focus my attention on the classroom, the one place in the academy where I could have the most impact, they became less intense. I became more passionate in my commitment to the art of teaching.

Engaged pedagogy not only compels me to be constantly creative in the classroom, it also sanctions involvement with students beyond that setting. I journey with students as they progress in their lives beyond our classroom experience. In many ways, I continue to teach them, even as they become more capable of teaching me. The important lesson that we learn together, the lesson that allows us to move together within and beyond the classroom, is one of mutual engagement.

I could never say that I have no idea of the way students respond to my pedagogy; they give me constant feedback. When I teach, I encourage them to critique, evaluate, make suggestions and interventions as we go along. Evaluations at

the end of a course rarely help us improve the learning experience we share together. When students see themselves as mutually responsible for the development of a learning community, they offer constructive input.

Students do not always enjoy studying with me. Often they find my courses challenge them in ways that are deeply unsettling. This was particularly disturbing to me at the beginning of my teaching career because I wanted to be like and admired. It took time and experience for me to understand that the rewards of engaged pedagogy might not emerge during a course. Luckily, I have taught many students who take time to reconnect and share the impact of our working together on their lives. Then the work I do as a teacher is affirmed again and again, not only by the accolades extended to me but by the career choices students make, their habits of being. When a student tells me that she struggled with the decision to do corporate law, joined such and such a firm, and then at the last minute began to reconsider whether this was what she felt called to do, sharing that her decision was influenced by the courses she took with me, I am reminded of the power we have as teachers as well as the awesome responsibility. Commitment to engaged pedagogy carries with it the willingness to be responsible, not to pretend that professors do not have the power to change the direction of our students' lives.

I began this collection of essays confessing that I did not want to be a teacher. After twenty years of teaching, I can confess that I am often most joyous in the classroom, brought closer here to the ecstatic than by most of life's experiences. In a recent issue of *Tricycle,* a journal of Buddhist thought, Pema Chodron talks about the ways teachers function as role models, describing those teachers that most touched her spirit:

> My models were the people who stepped outside of the
> conventional mind and who could actually stop my

mind and completely open it up and free it, even for a
moment, from a conventional, habitual way of looking
at things. . . . If you are really preparing for ground-
lessness, preparing for the reality of human existence,
you are living on the razor's edge, and you must
become used to the fact that things shift and change.
Things are not certain and they do not last and you do
not know what is going to happen. My teachers have
always pushed me over the cliff. . . .

Reading this passage, I felt deep kinship, for I have sought
teachers in all areas of my life who would challenge me beyond
what I might select for myself, and in and through that chal-
lenge allow me a space of radical openness where I am truly
free to choose—able to learn and grow without limits.

The academy is not paradise. But learning is a place where
paradise can be created. The classroom, with all its limitations,
remains a location of possibility. In that field of possibility we
have the opportunity to labor for freedom, to demand of our-
selves and our comrades, an openness of mind and heart that
allows us to face reality even as we collectively imagine ways to
move beyond boundaries, to transgress. This is education as
the practice of freedom.

This page intentionally left blank

Index